TEDRIC
THE HOUSE MOUSE ™

GRAPHIC DESIGN, JACKET DESIGN,
PHOTOGRAPHY, BOOK DESIGN,
EDITED AND WRITTEN BY

PETER JOHANNES

To Samanti & Cameron...
...Enjoy!
2010

PAXART
PUBLISHING
PAX-ART.COM
A DIVISION OF
RAVENWOOD STUDIOS INC.
ROBBINSTON, MAINE

Library of Congress Control Number : 2009927914

ISBN 978-0-615-29542-8
First printing 2009

Published by PaXart Publishing
Ravenwood Center
633 U.S. Rt.1 Robbinston, Maine 04671

This book may be ordered from the publisher,
but try your bookstore first!

Visit us on the web!

www.pax-art.com

This book is Dedicated to
Marcy, Adrian and Jordan
and
Louisa Francisca Overwater

who loved all creaturesgreat and small.

With great appreciation to Jordan Michel
Head Sherpa and Chief Mouse Wrangler

With special thanks to
Tevye and his beautiful daughter
Juliette and her lovely Leonard

Tedric says, "These are things that I can find in this book, can you?"
As you read this book, see if you can spot the following things:
(You may make a copy of this page, so that you leave this book unmarked for the next reader.)

- [] apples
- [] ball
- [] berries
- [] bichon frise
- [] blue jay
- [] bookend
- [] broom
- [] bumble bee
- [] candle
- [] cat
- [] chickadee
- [] chimney
- [] clock
- [] creel
- [] electric lamp
- [] eye glasses

- [] flower pot
- [] goat
- [] goldfinch
- [] hammer
- [] horse
- [] hose
- [] leaded glass
- [] mailbox
- [] monkshood
- [] 3 moons
- [] mouse shadow
- [] mushroom
- [] painting
- [] pine cone
- [] puffins
- [] rock

- [] ruler
- [] saucer
- [] sheep
- [] shingles
- [] shoe
- [] spray nozzle
- [] table cloth
- [] tea cup
- [] teddy bear
- [] toy horse
- [] toy rabbits
- [] toy truck
- [] truth
- [] wagon wheels
- [] water can
- [] window

Tedric
The house
mouse ™

By Peter Johannes

There once was a place by the deep blue sea. By a field and a wood, is where it stood.

It was a house in the country, quite overgrown.

But it was more than a house....it was really a home!

There was a dog and a cat, and that was that.

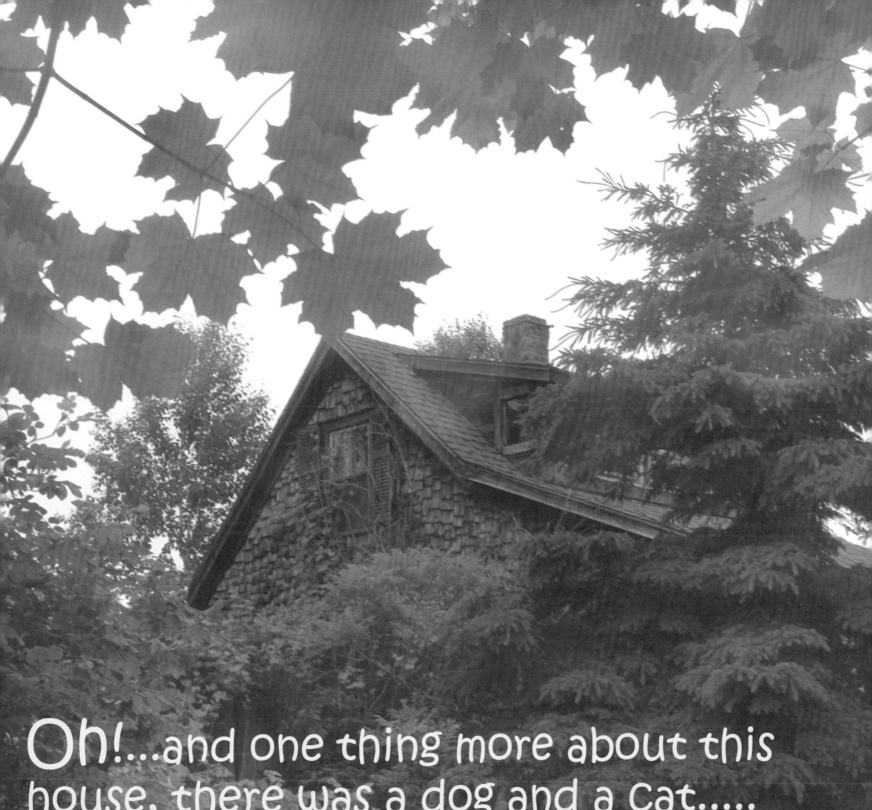

OH!...and one thing more about this house, there was a dog and a cat..... but also ...

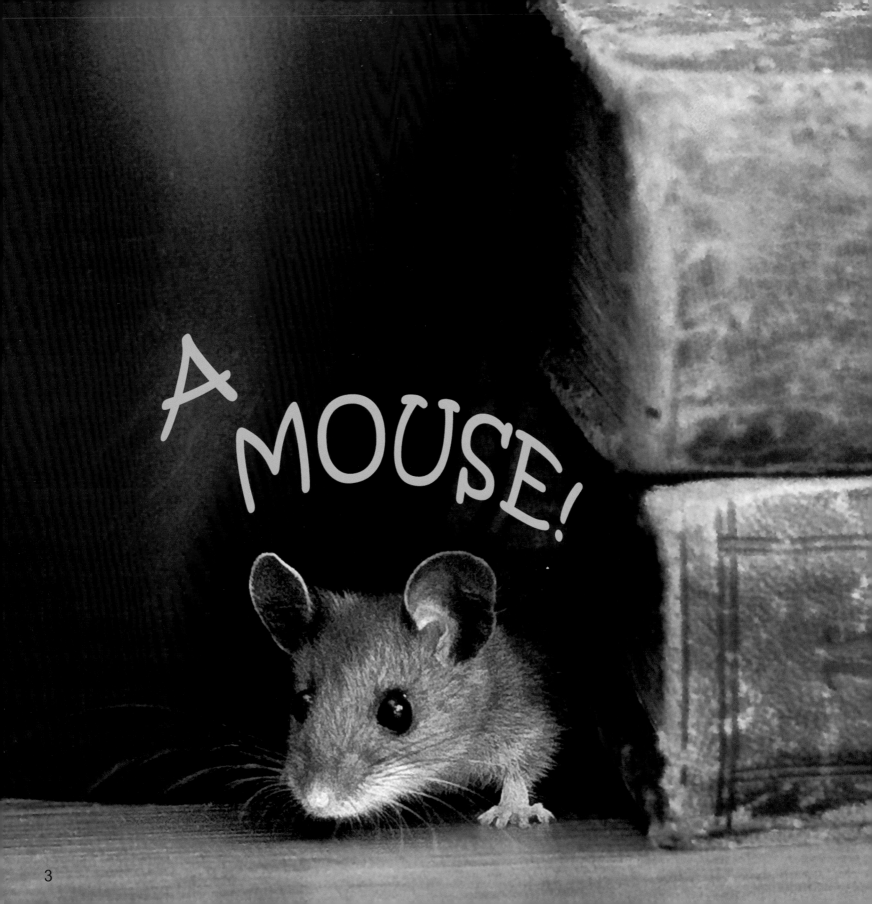

There were people of course, in this little house, but our story today is about a wee **mouse!**

He was born in a wood pile in the old shed......

and his wee name was **Tedric,** so everyone said.

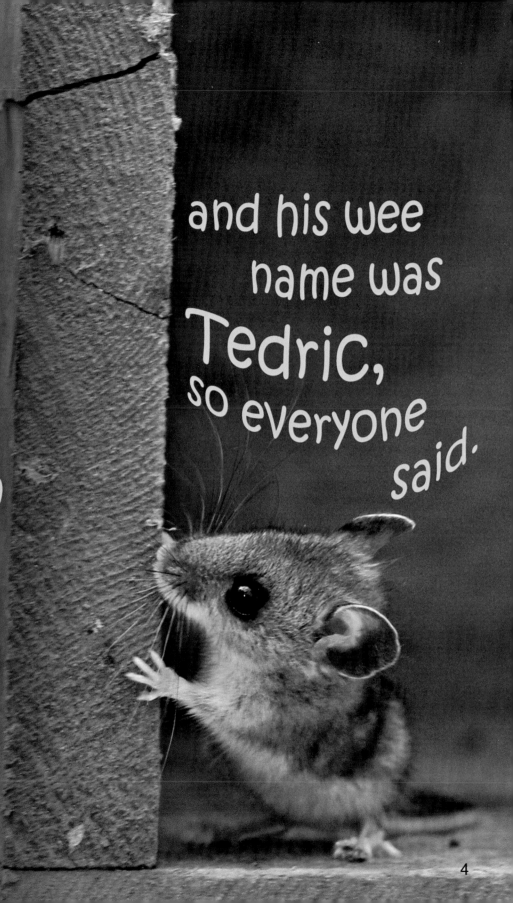

4

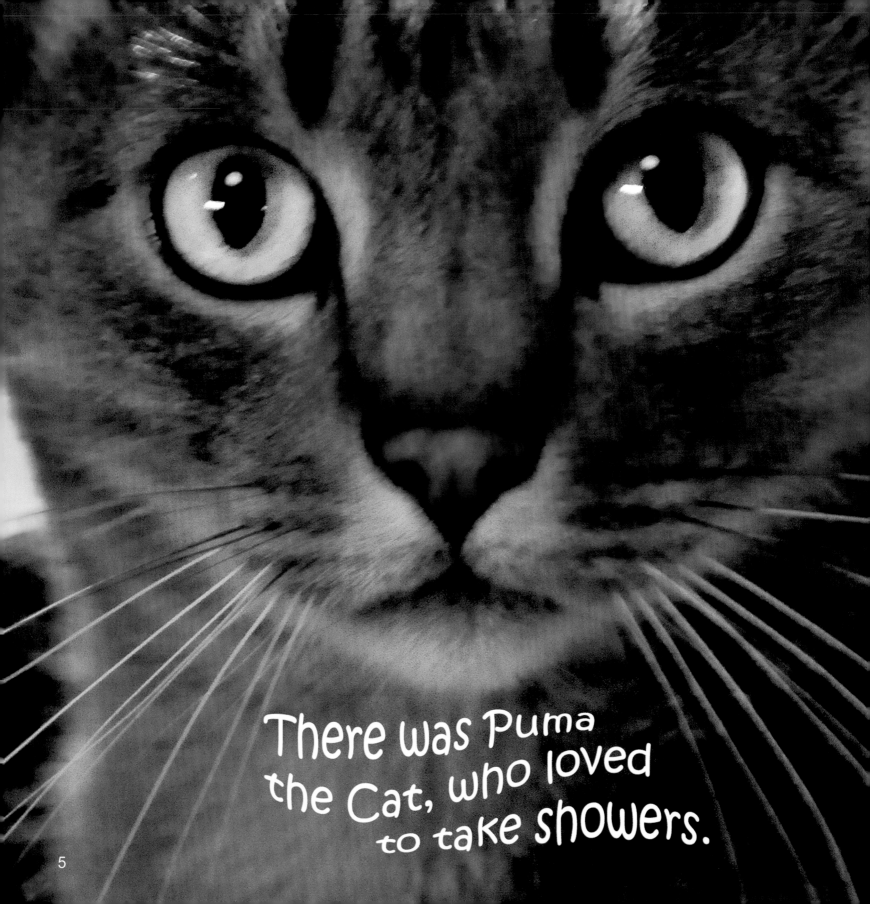

There was Puma the Cat, who loved to take showers.

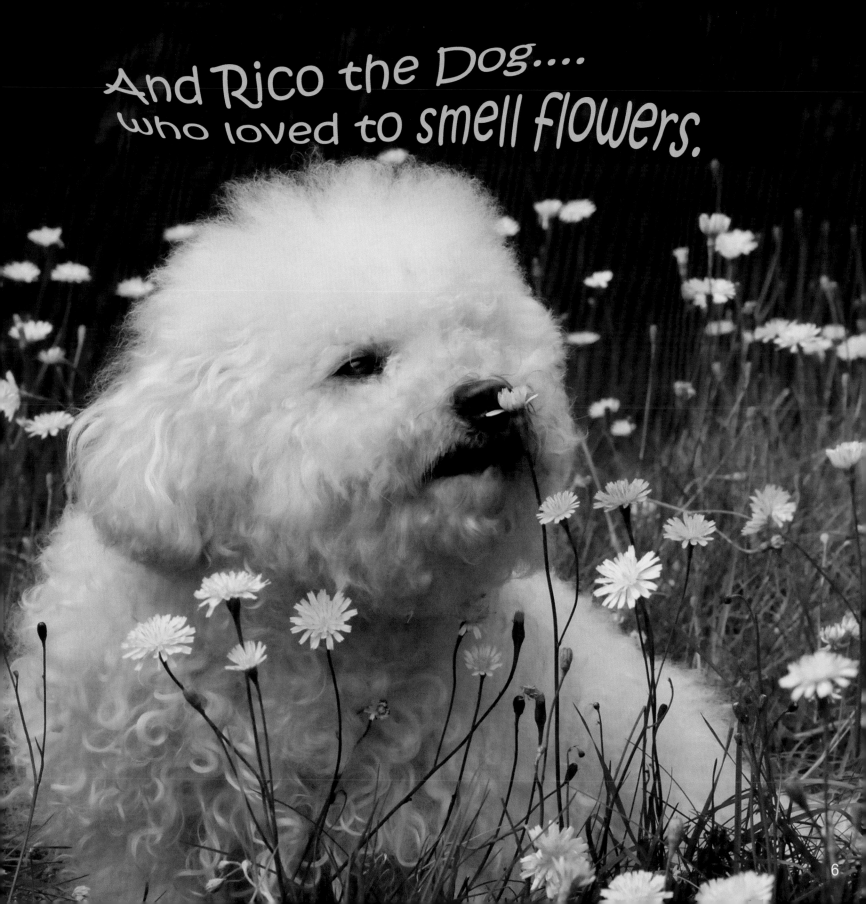

And Rico the Dog....
who loved to smell flowers.

Rico and Puma were brothers
but from different
mothers.

Rico's job was
cleaning
Ears.

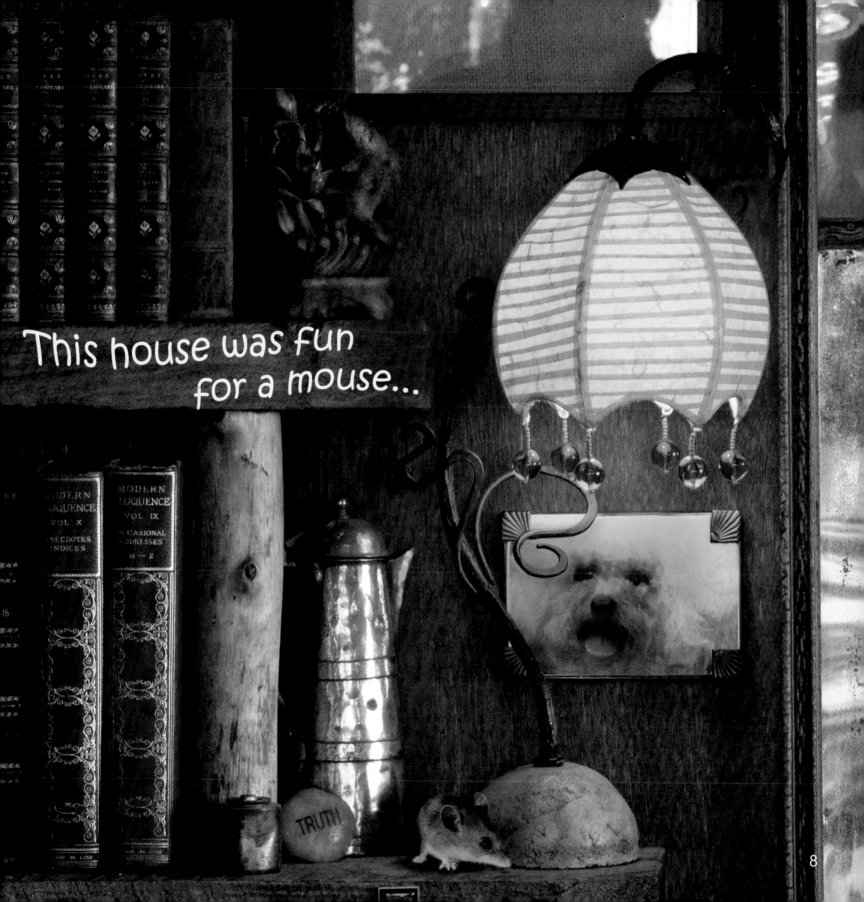

This house was fun for a mouse...

there were good
books to read...

There were fun things to see and fun things to do....

MEMORIAL OF THE Rev. JAMES BRAINERD TYLER

REMINISCENCES OF A JOURNALIST C.T. CONGDON

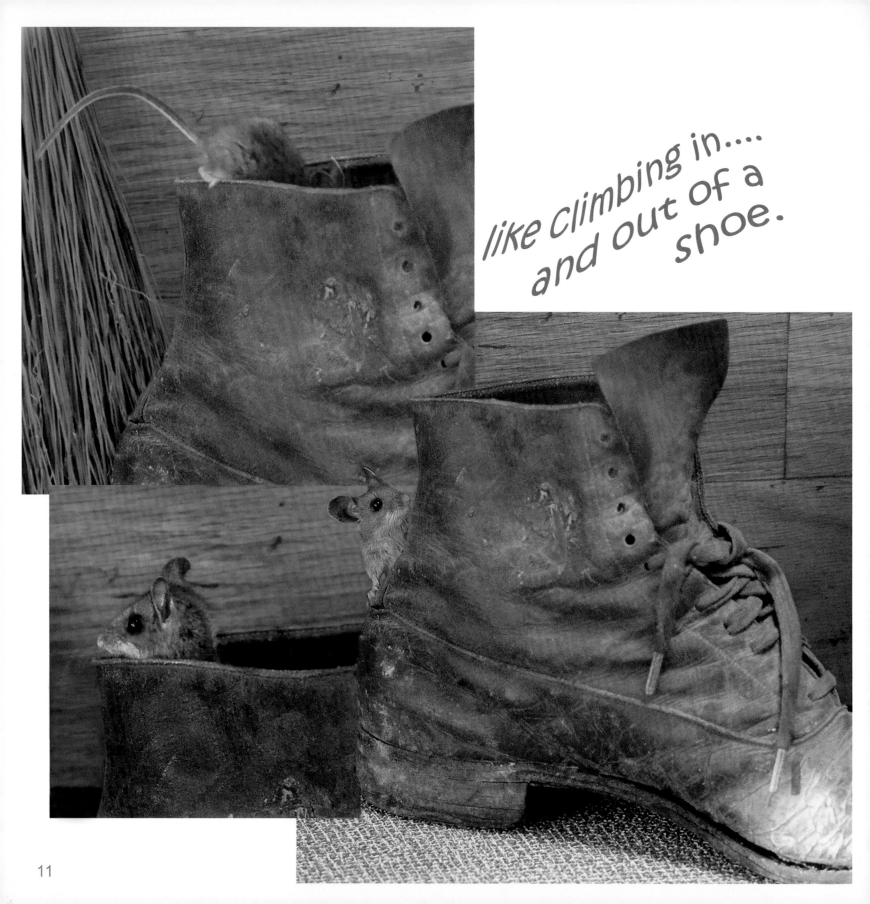

like climbing in....
and out of a shoe.

11

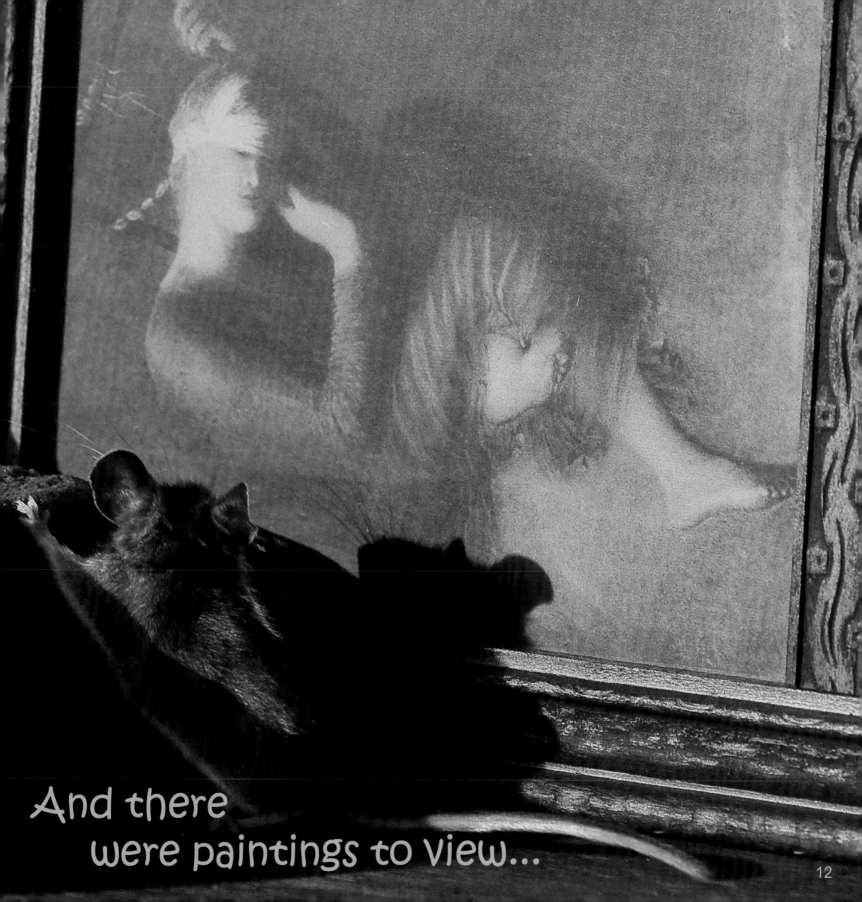

And there
were paintings to view...

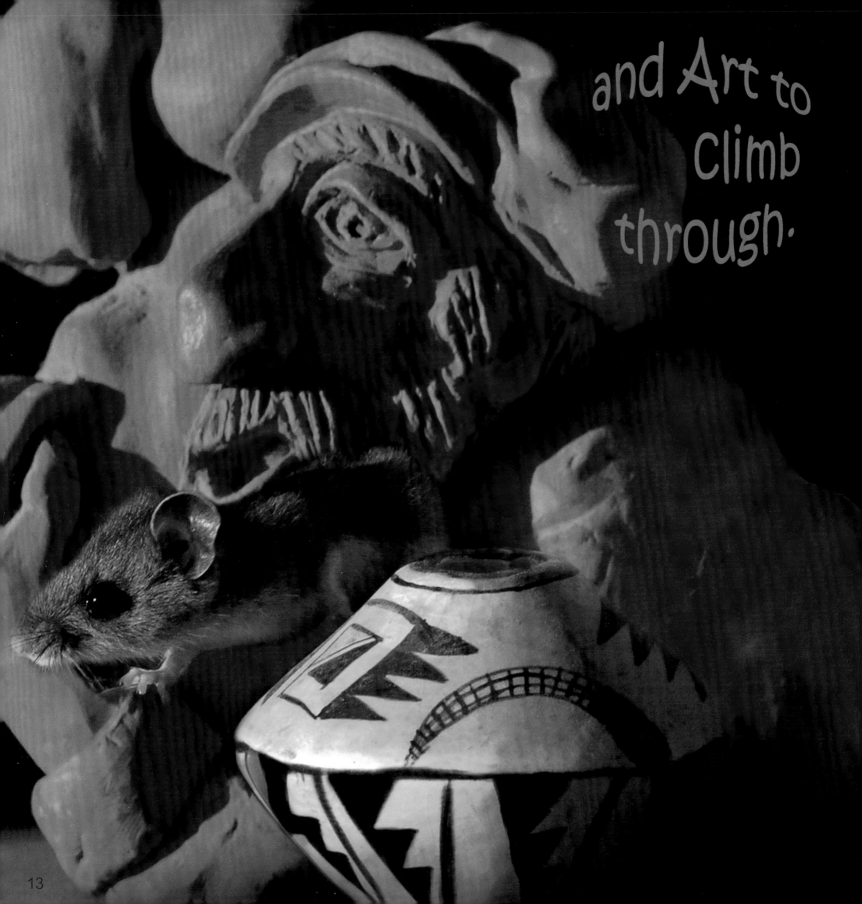

and Art to climb through.

13

Tedric loved Fine Art...
don't you?

14

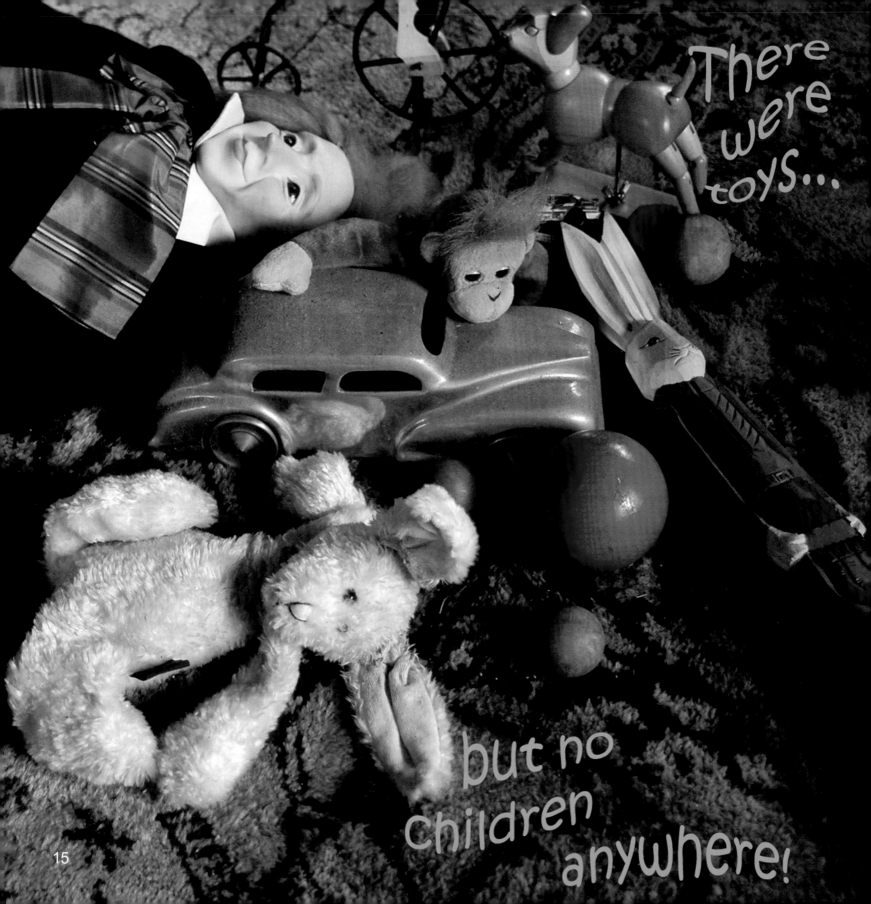

There were toys...

but no children anywhere!

15

So he could pretend to drive,
without a care...

and visit his friend
the Teddy Bear.

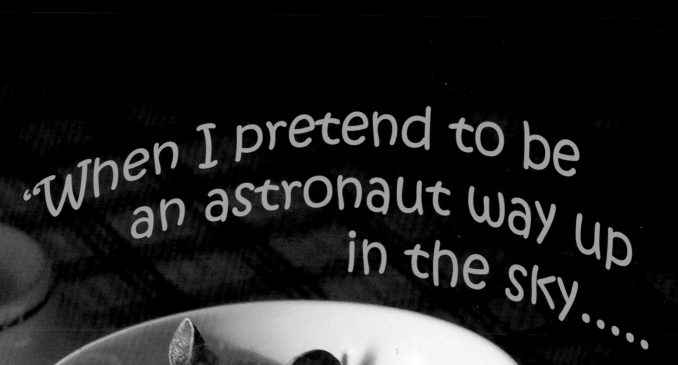

"When I pretend to be an astronaut way up in the sky.....

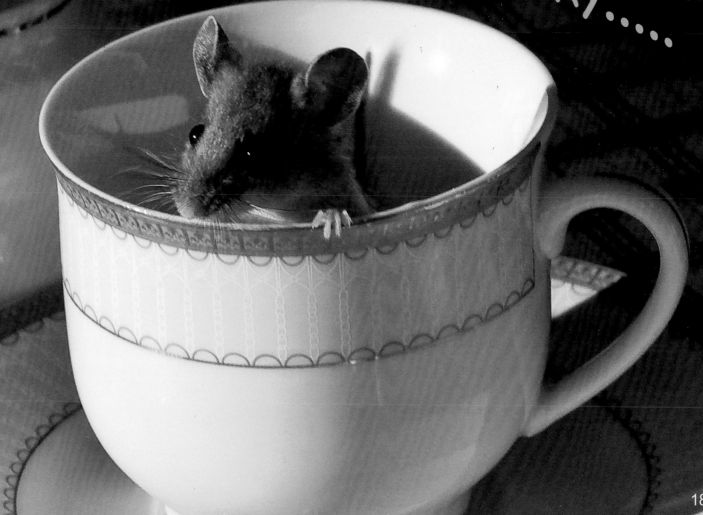

this broom could be my rocket ship", said Tedric with a sigh.

"I'd love to be just like a

bird...
and spread my
wings to fly."

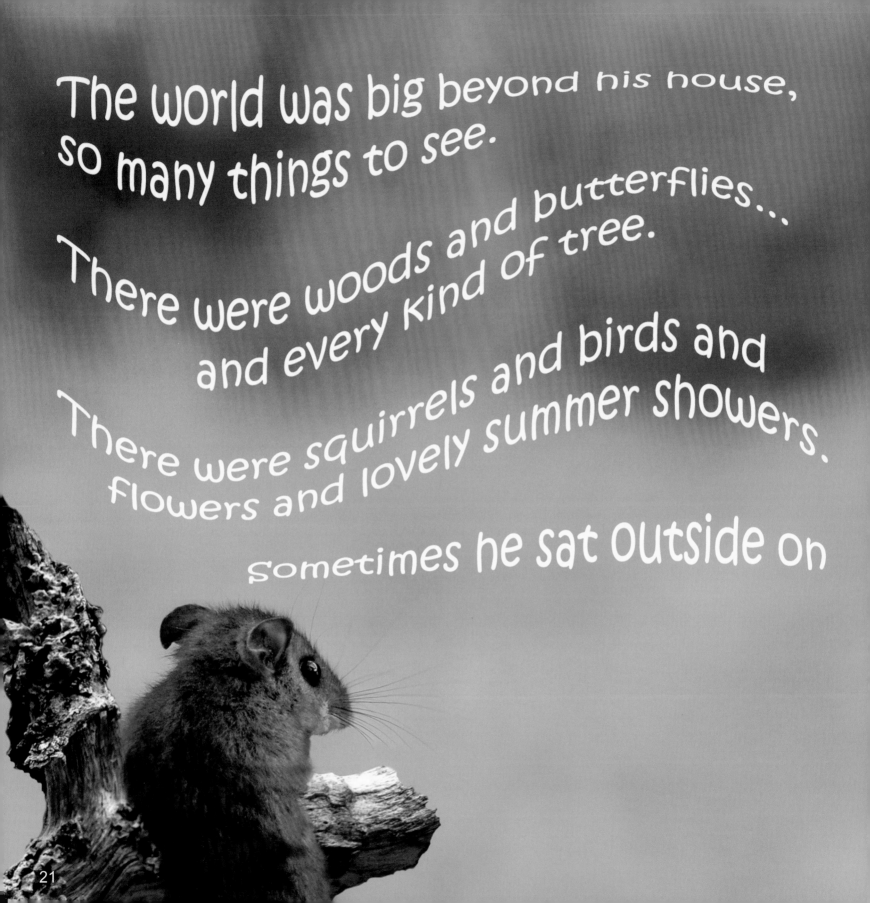

The world was big beyond his house, so many things to see.

There were woods and butterflies... and every kind of tree.

There were squirrels and birds and flowers and lovely summer showers.

Sometimes he sat outside on

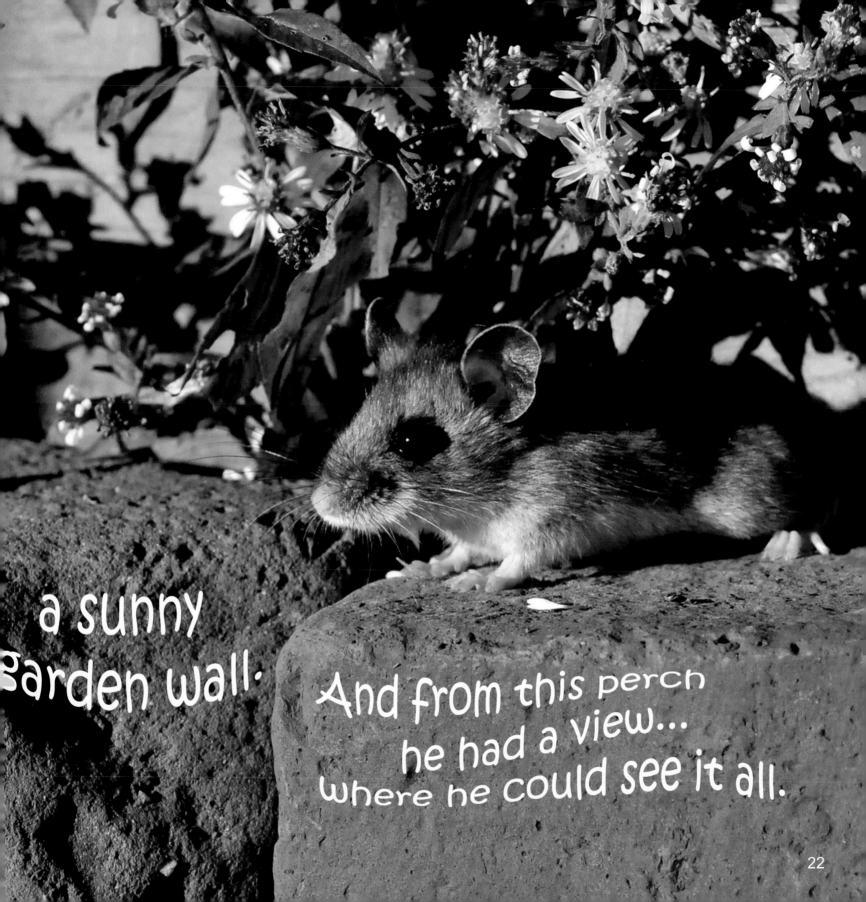

a sunny
garden wall.

And from this perch
he had a view...
where he could see it all.

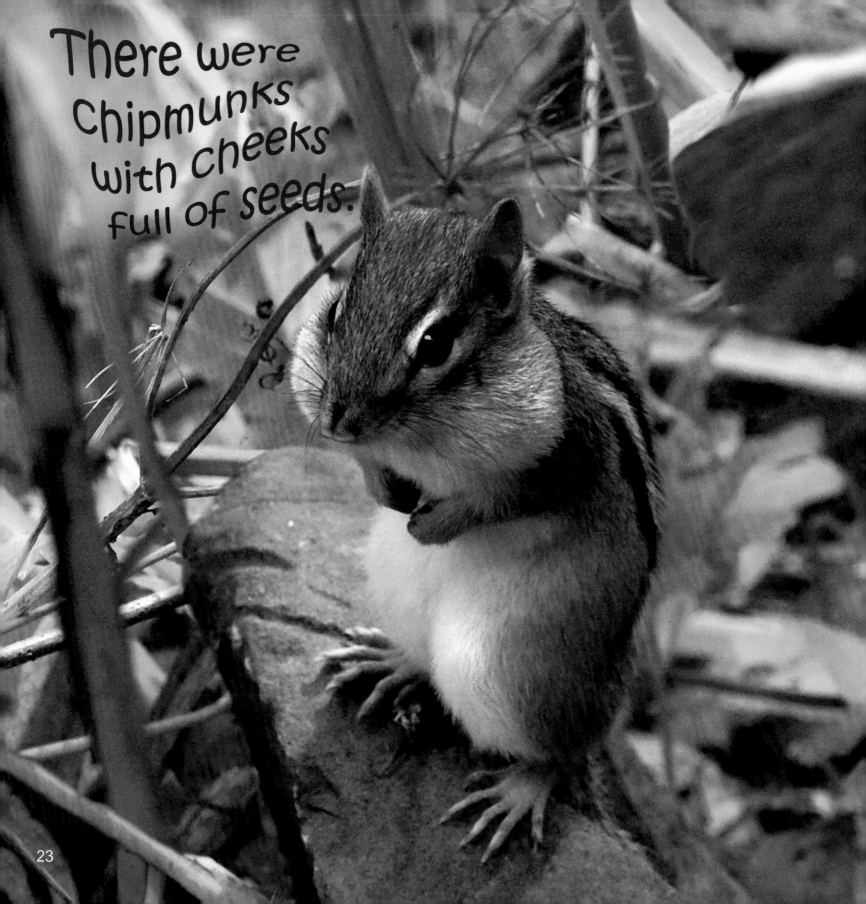

There were
Chipmunks
with cheeks
full of seeds.

23

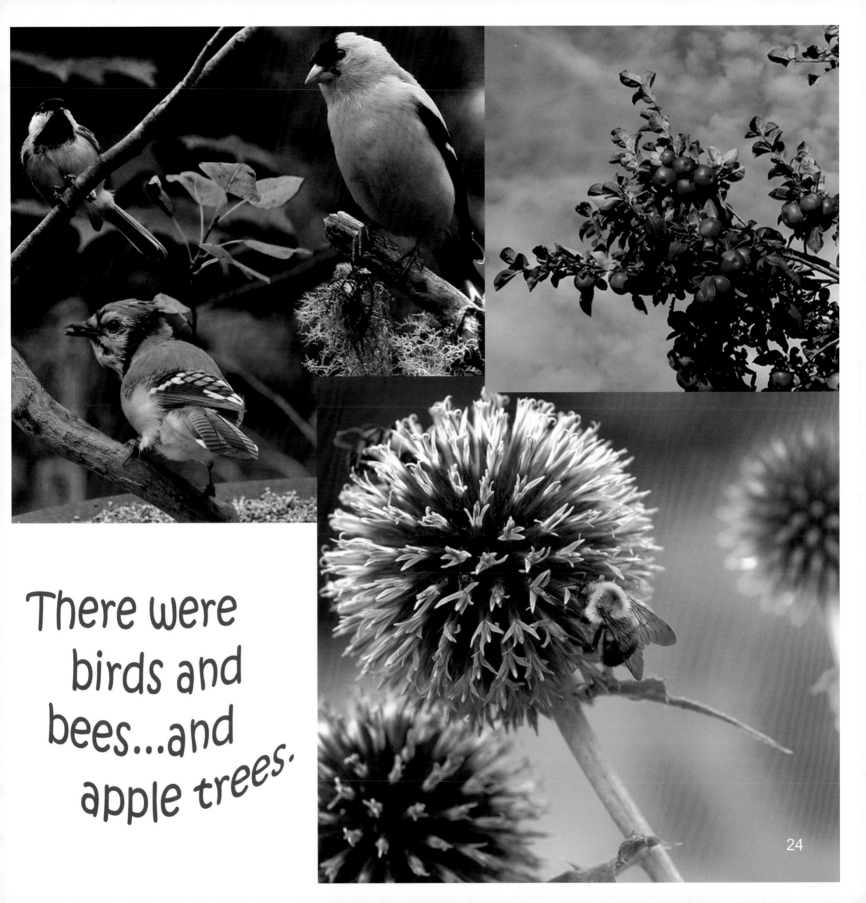

There were
birds and
bees...and
apple trees.

24

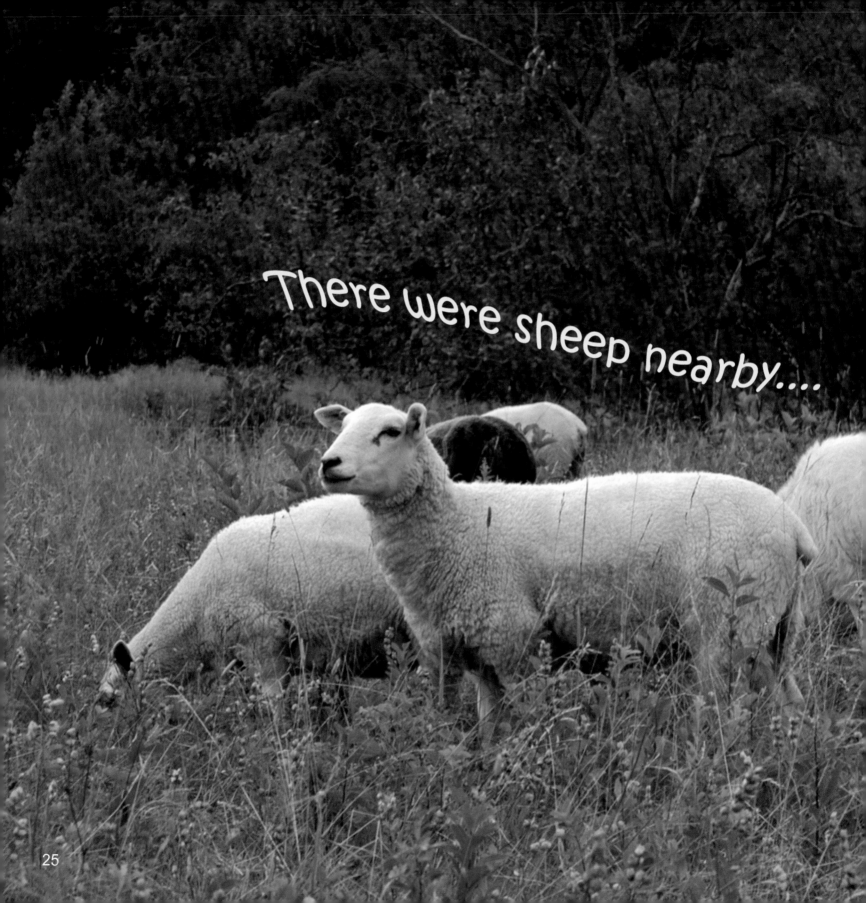

There were sheep nearby....

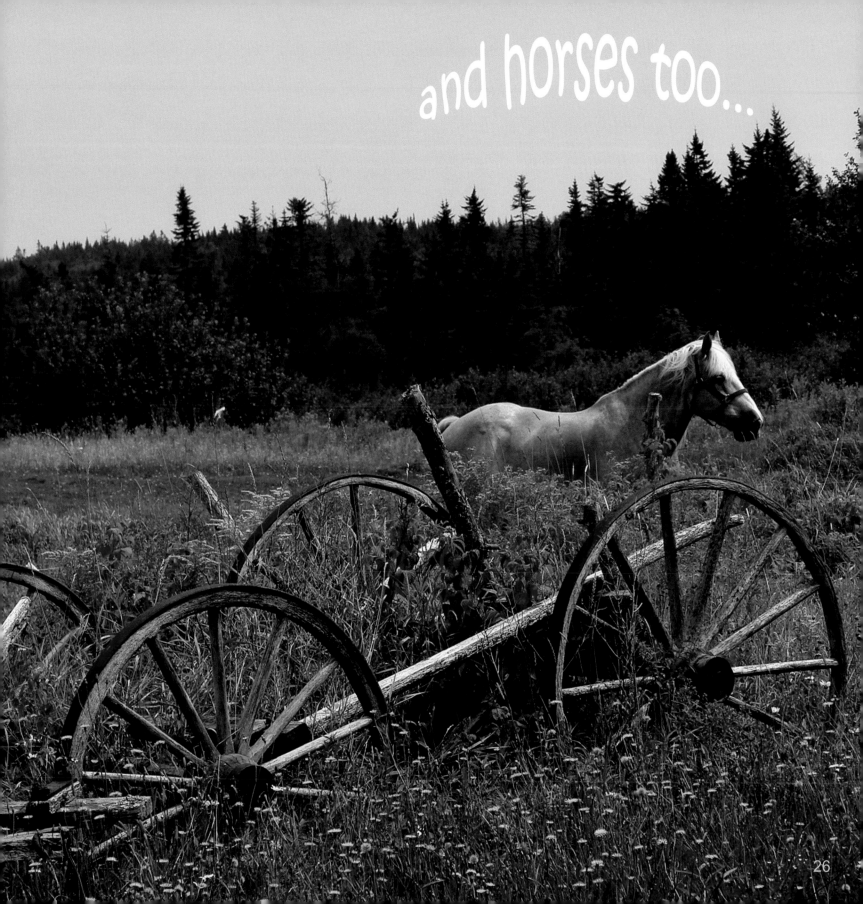

and horses too...

and
even a goat
named Shoobaloo.

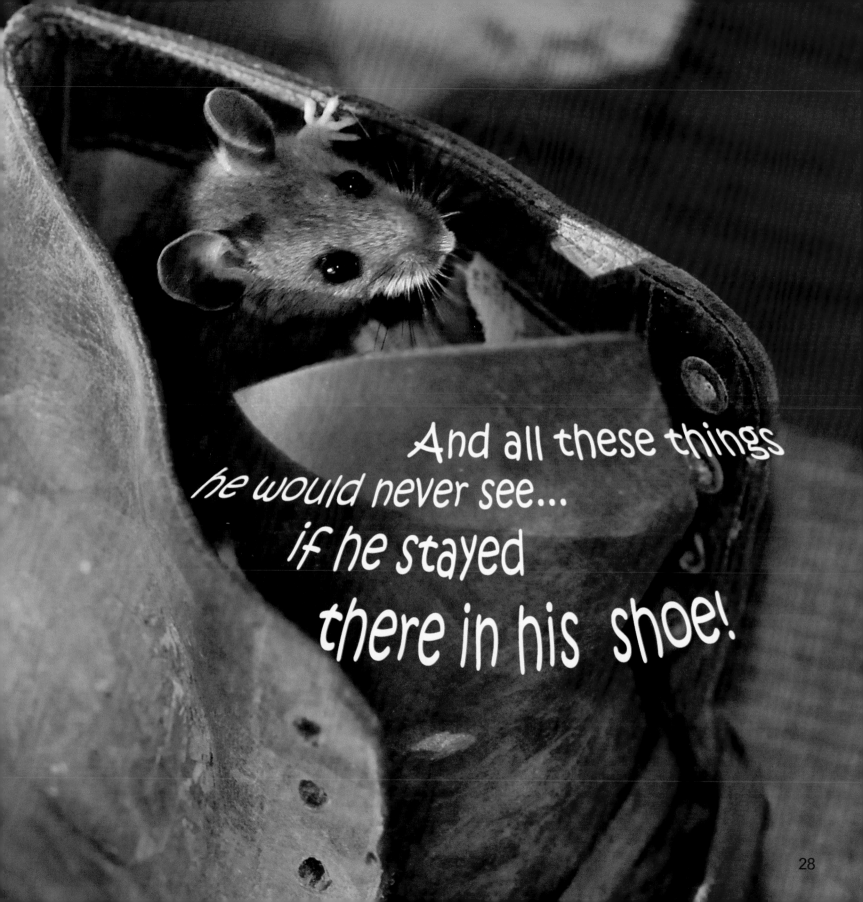

And all these things
he would never see...
if he stayed
there in his shoe!

Meanwhile...

29

back at the
house, the
day was moving on.

The hands of the clock read almost four.

It was time for
the cat's milk...
down on the floor.

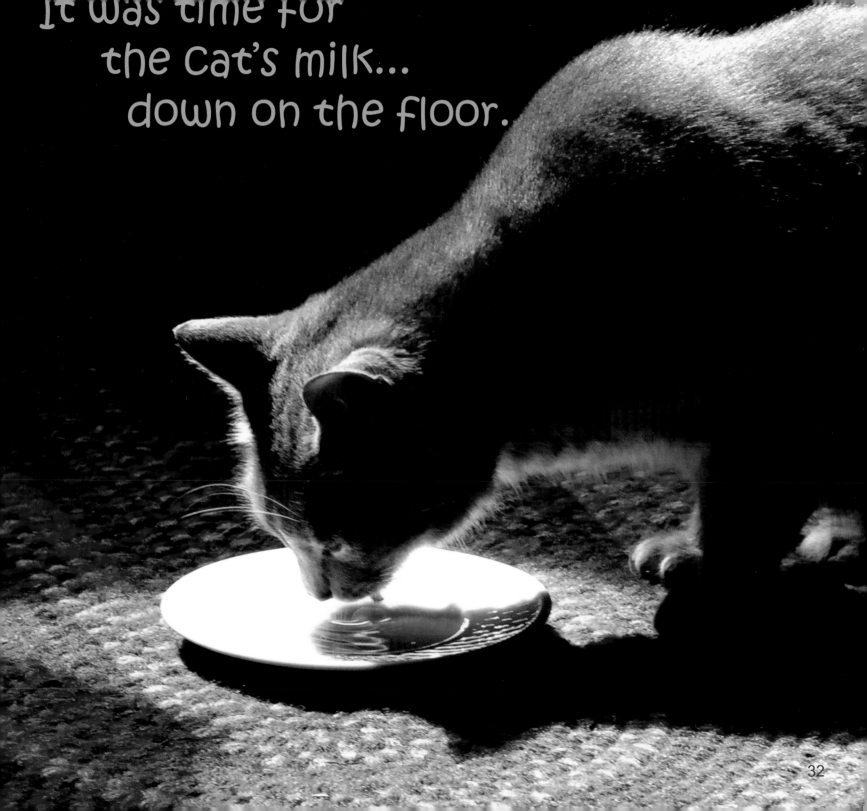

32

"Mmm...a drink of milk would sure be good!

too bad the cat's in the neighborhood."

33

He climbed up the tall books to look out for the cat.

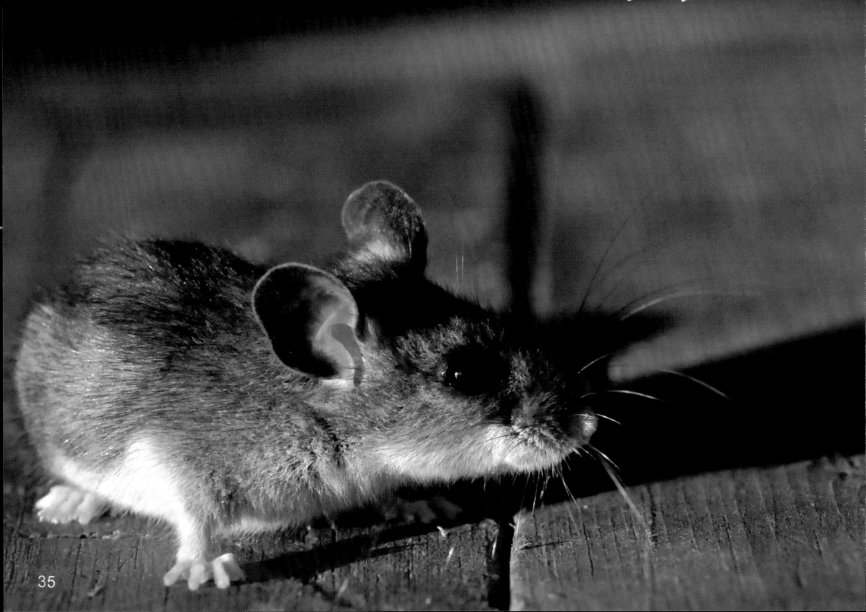

He looked straight upand saw

THE CAT!

The Cat looked back! And that was that.

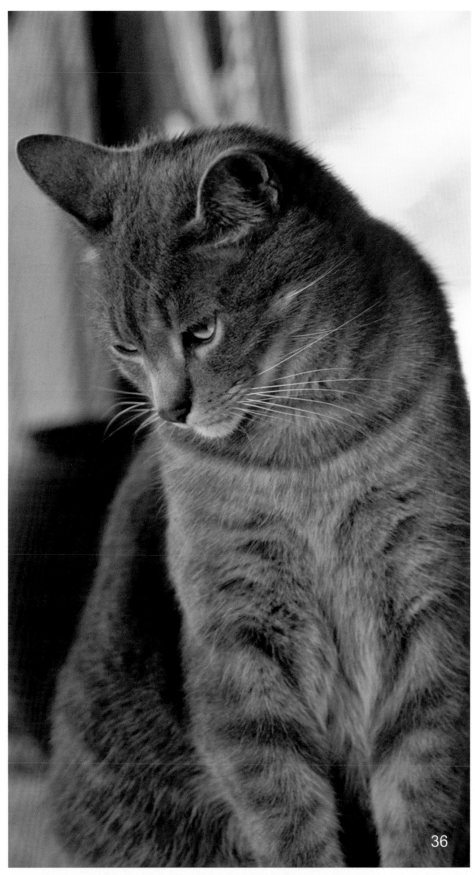

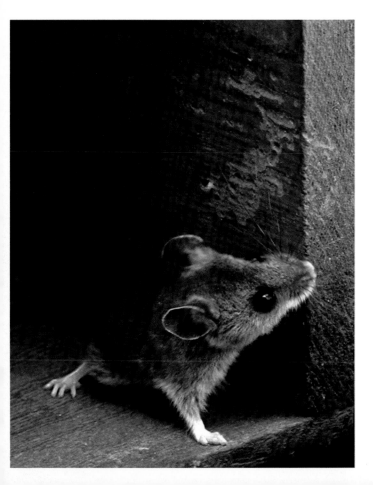

36

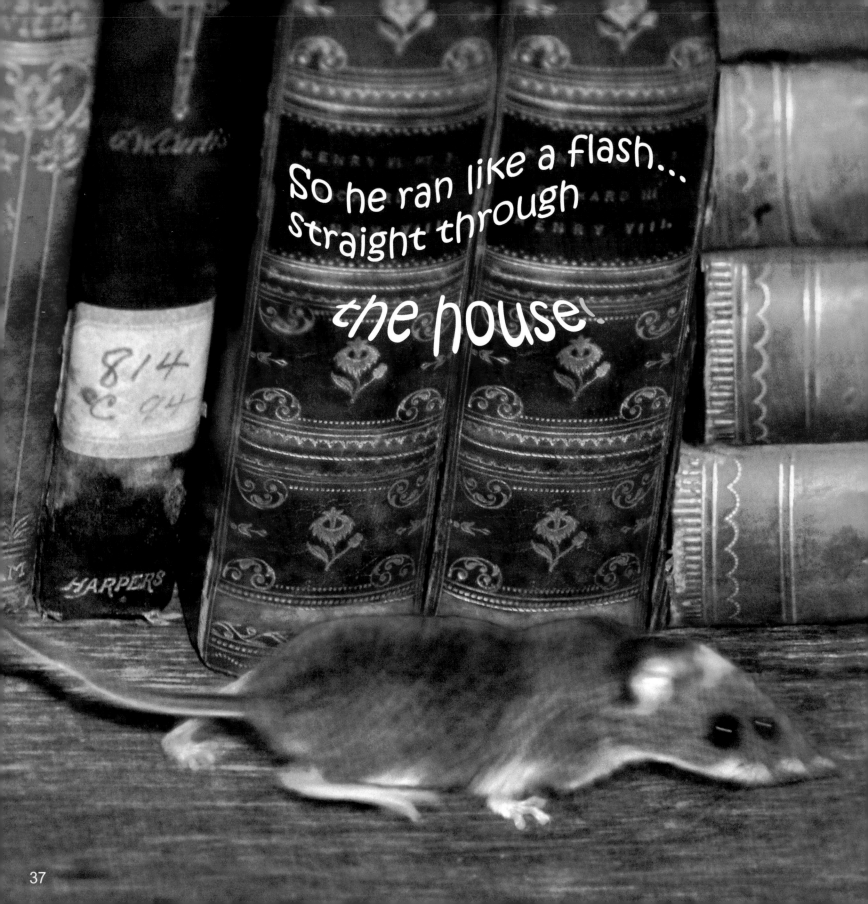

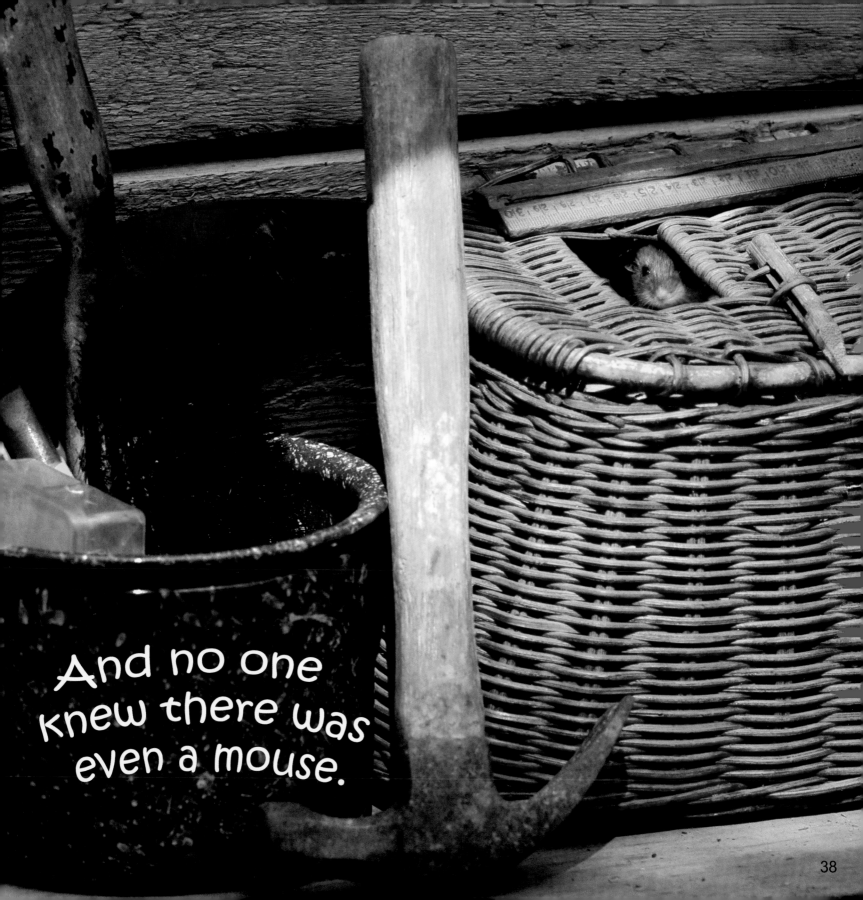

And no one knew there was even a mouse.

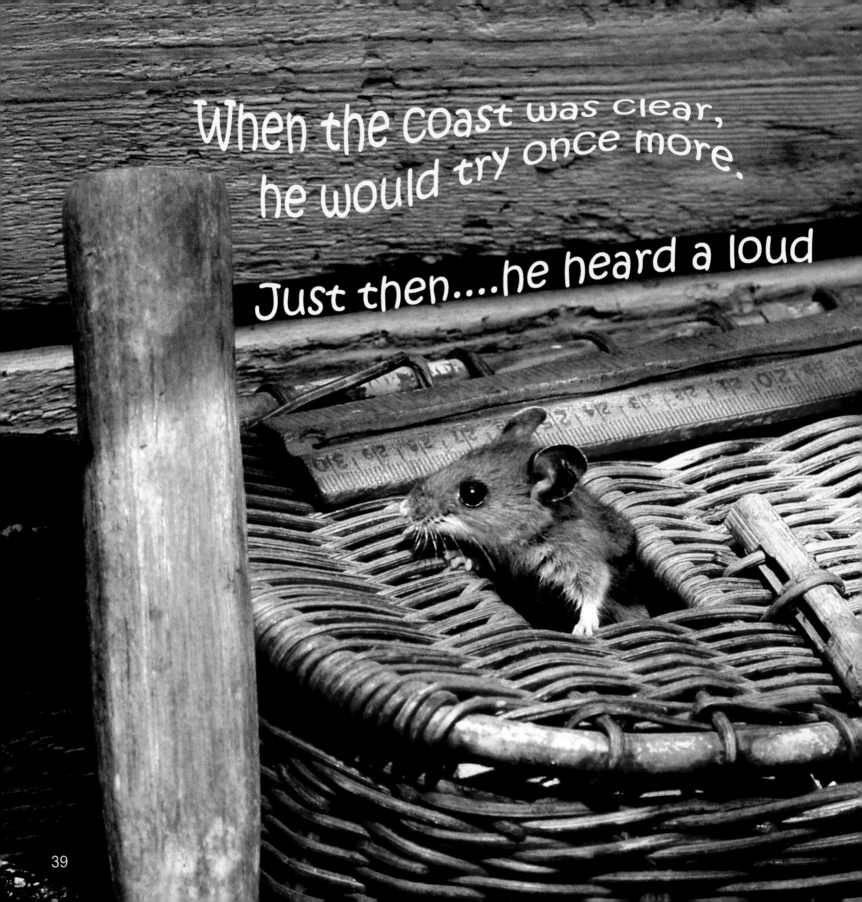

When the coast was clear,
he would try once more.

Just then....he heard a loud

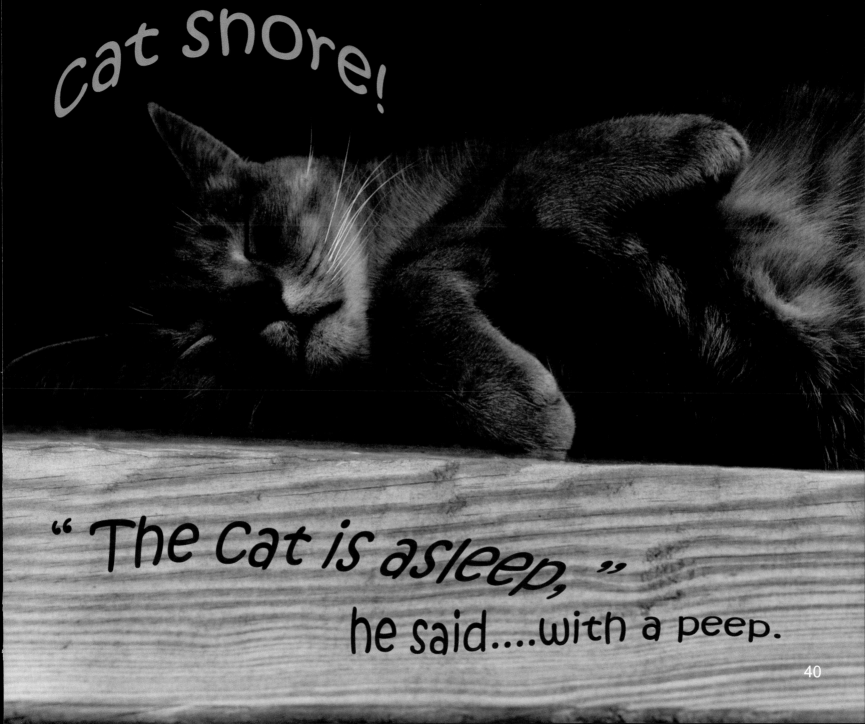

Cat snore!

" The cat is asleep, "
he said....with a peep.

40

So he flew past the mirror and down through the house...

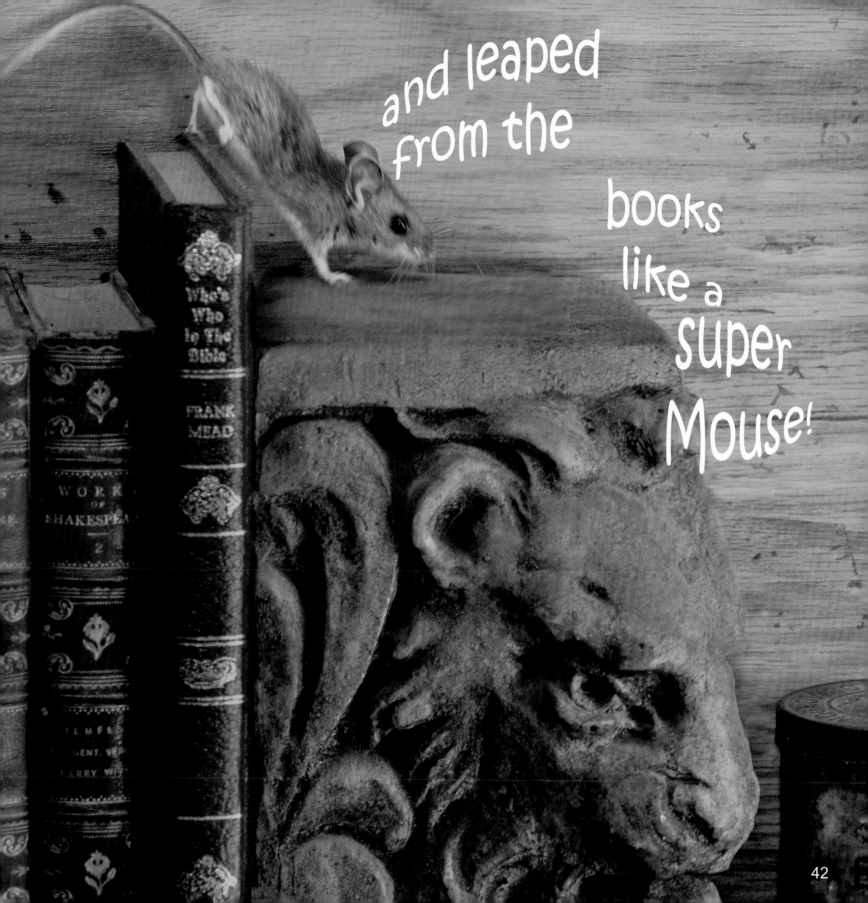

and leaped from the books like a super Mouse!

And there was the prize.... on the rug made of wool.

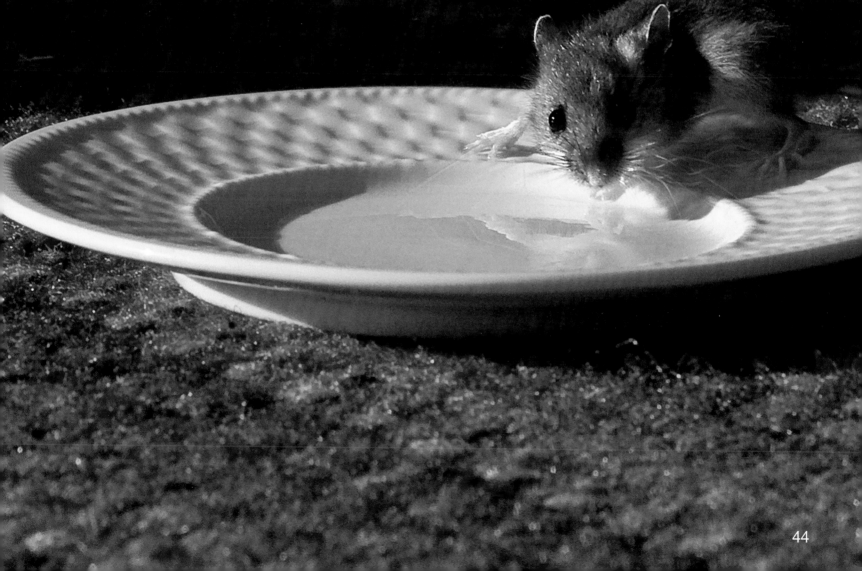

And so he drank cool milk until his belly was full.

Now he was ready for beddy. But first, if you please...

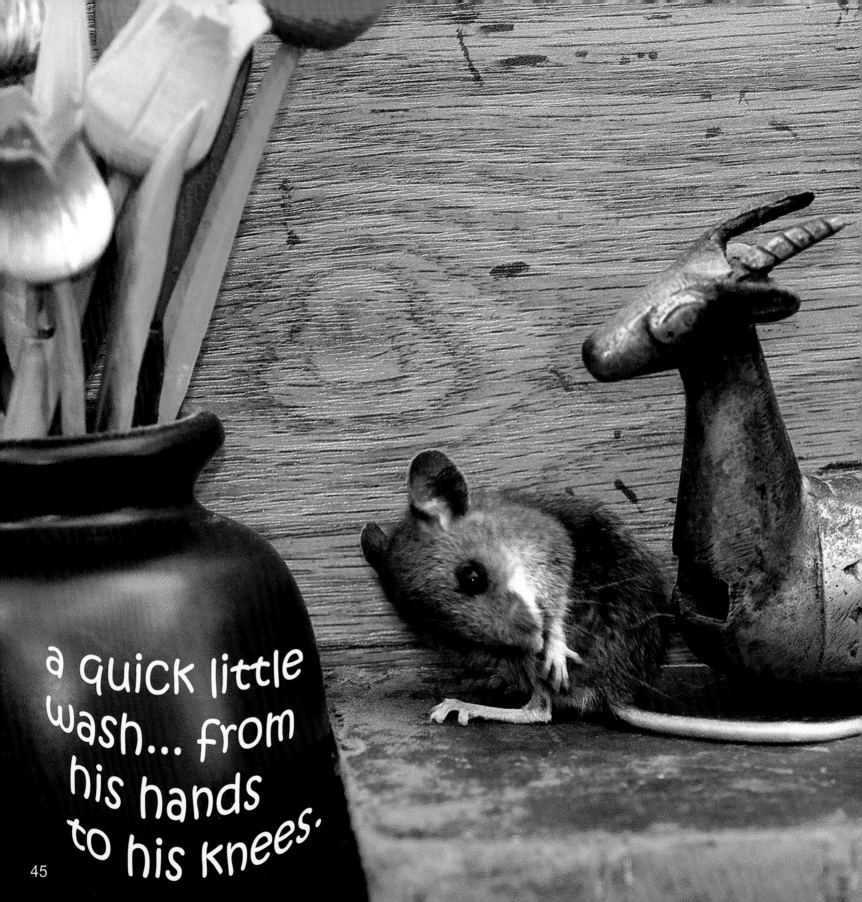

a quick little wash... from his hands to his knees.

45

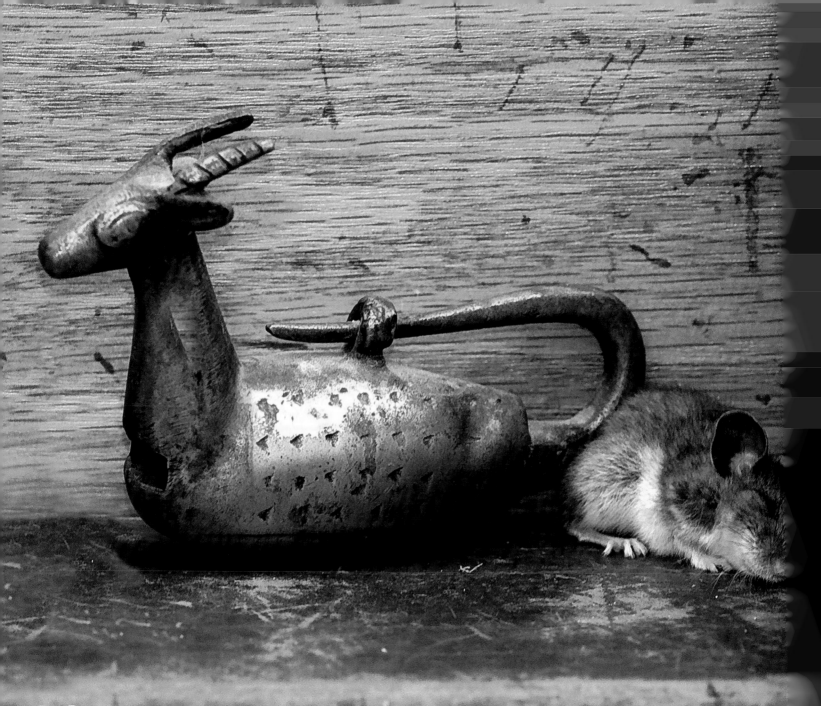

When his eyes went

sleepy.... the rest of him
soon followed.

4

The next
morning, Tedric sat
at the window sill.
He dreamed of the forest
just beyond the hill.
The woods were like....
nothing that he knew.

He said, "I just need a hole...

that I can slide through."

In the garden shed he found a hose that went through a crack.

So.....

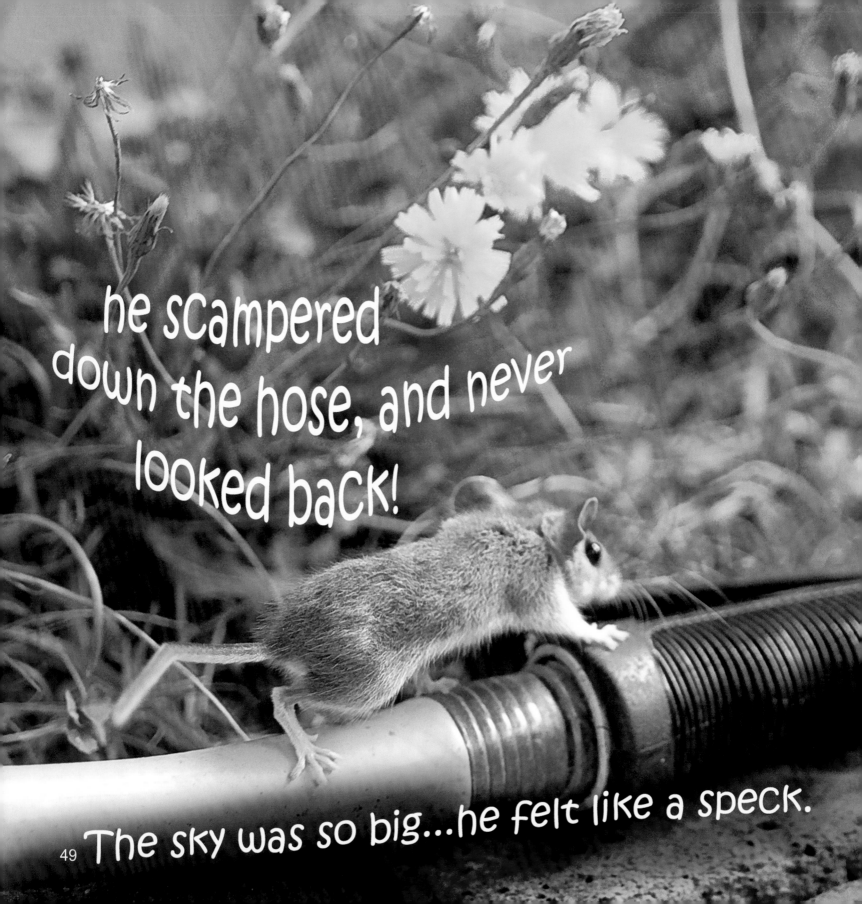

he scampered down the hose, and never looked back!

The sky was so big...he felt like a speck.

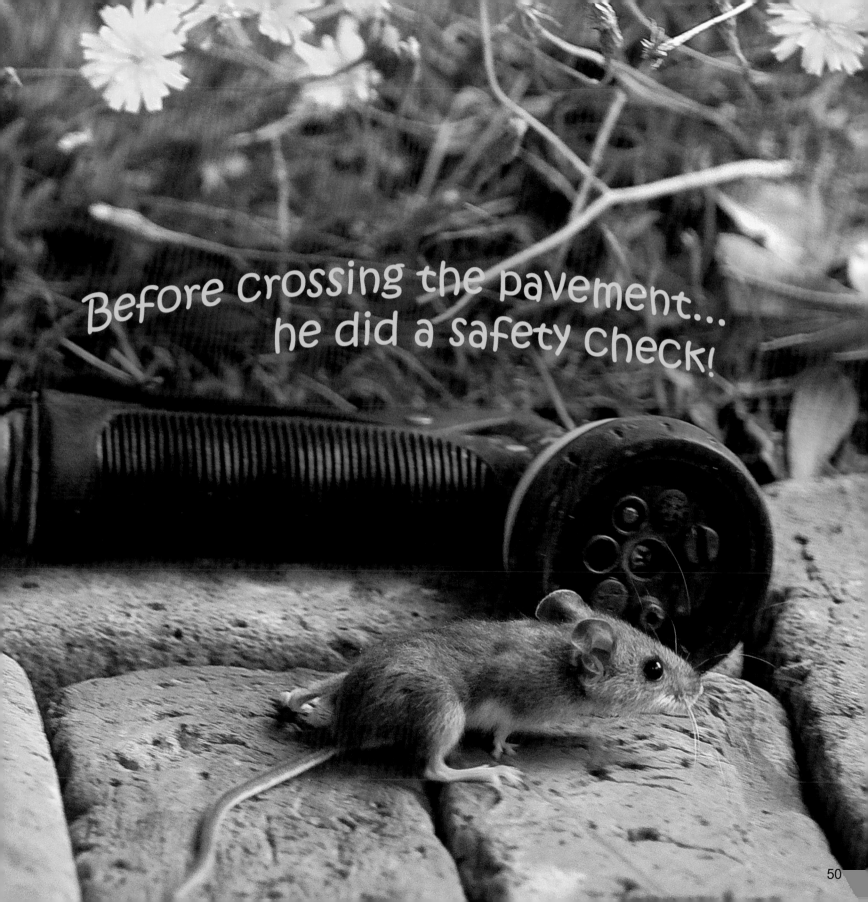

Before crossing the pavement... he did a safety check!

Blue Jay said from above, "Look out for the watch cat, Teddy! He's sneaking around.... and he's ready."

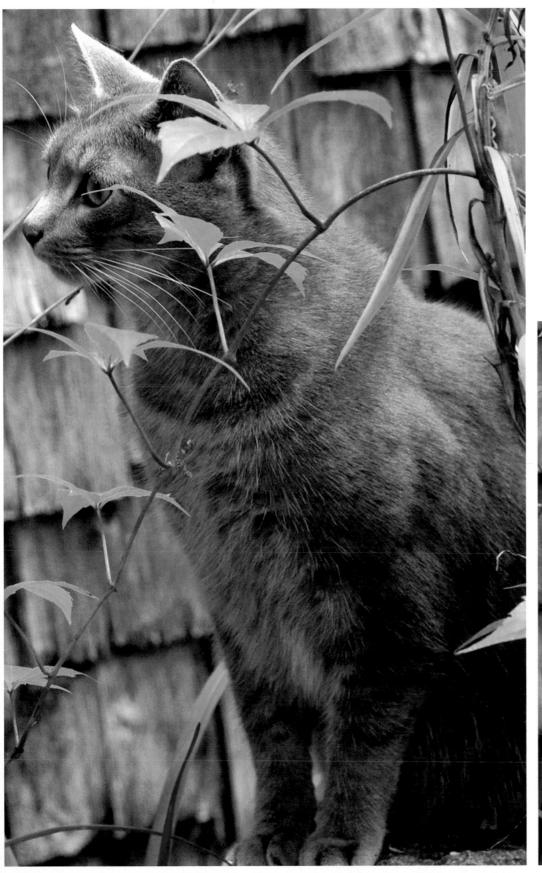

Puma the watchcat was Lord of the house. No one got by him...

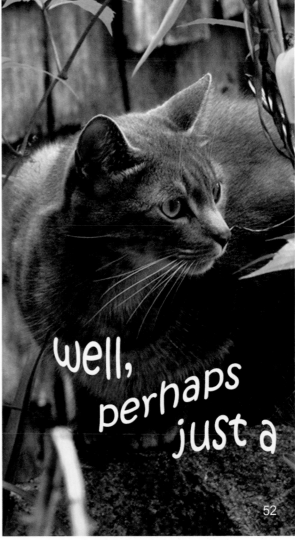

well, perhaps just a

52

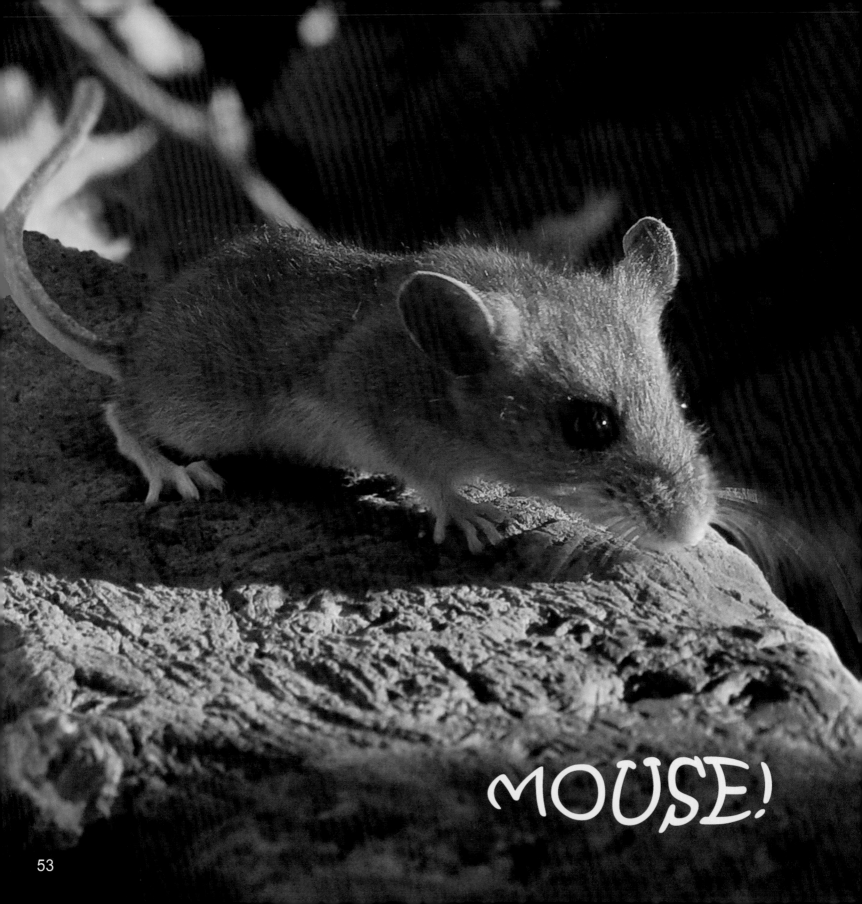

MOUSE!

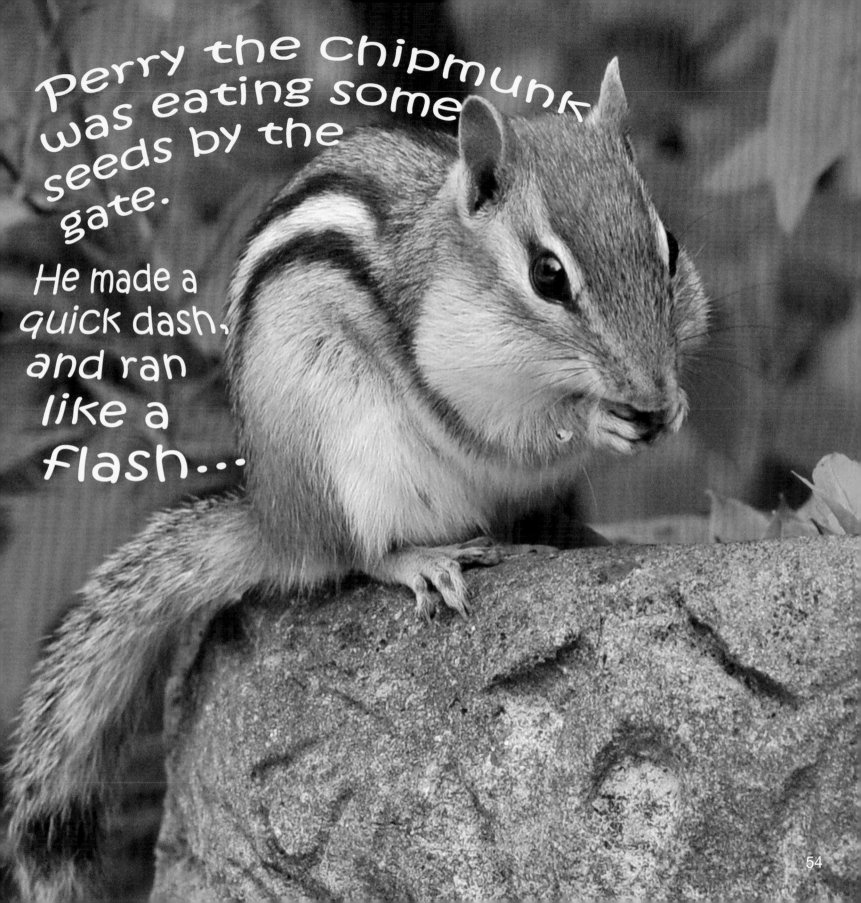

Perry the Chipmunk was eating some seeds by the gate.

He made a quick dash, and ran like a flash...

54

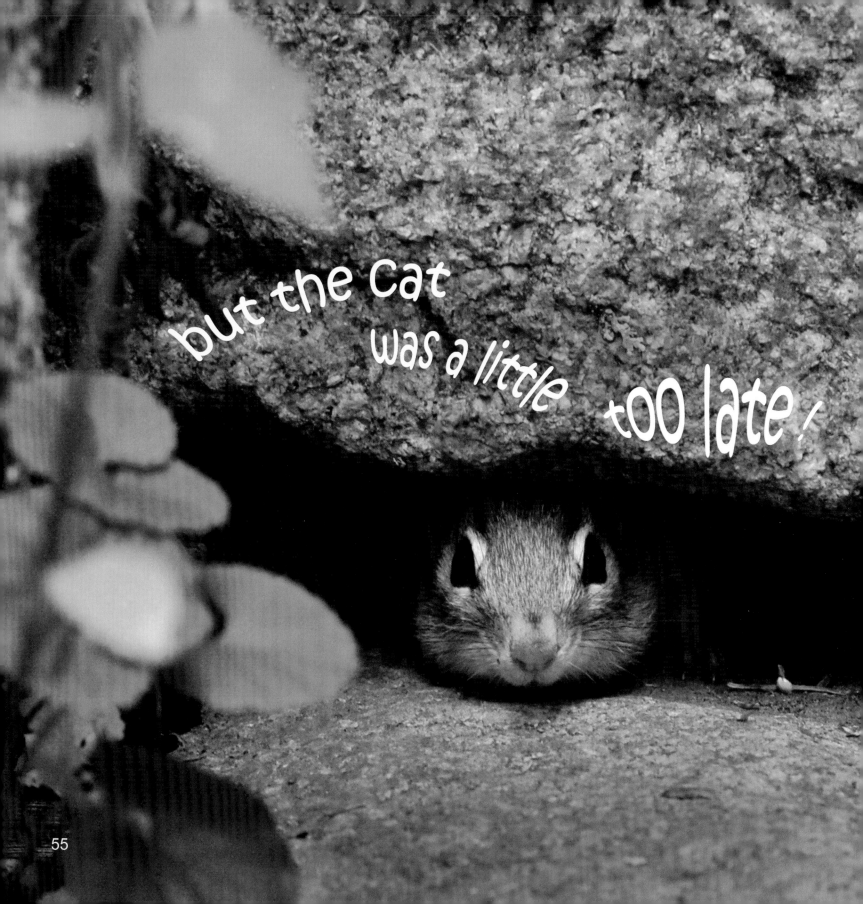

but the cat was a little too late!

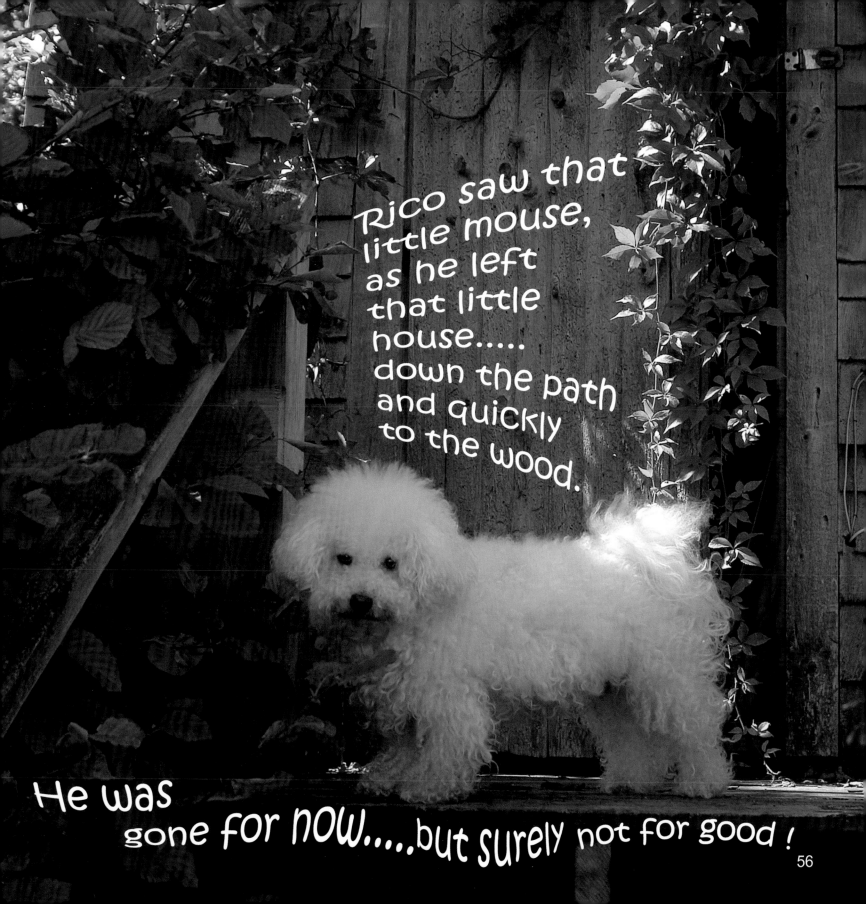

Rico saw that little mouse, as he left that little house..... down the path and quickly to the wood.

He was gone for now.....but surely not for good !

Tedric stopped and looked back at the world he knew.

Then with a big brave mouse breath...

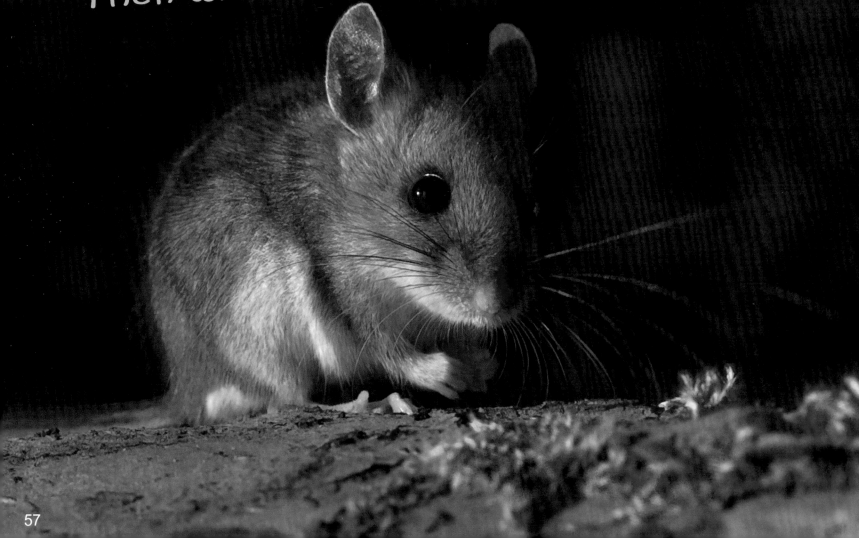

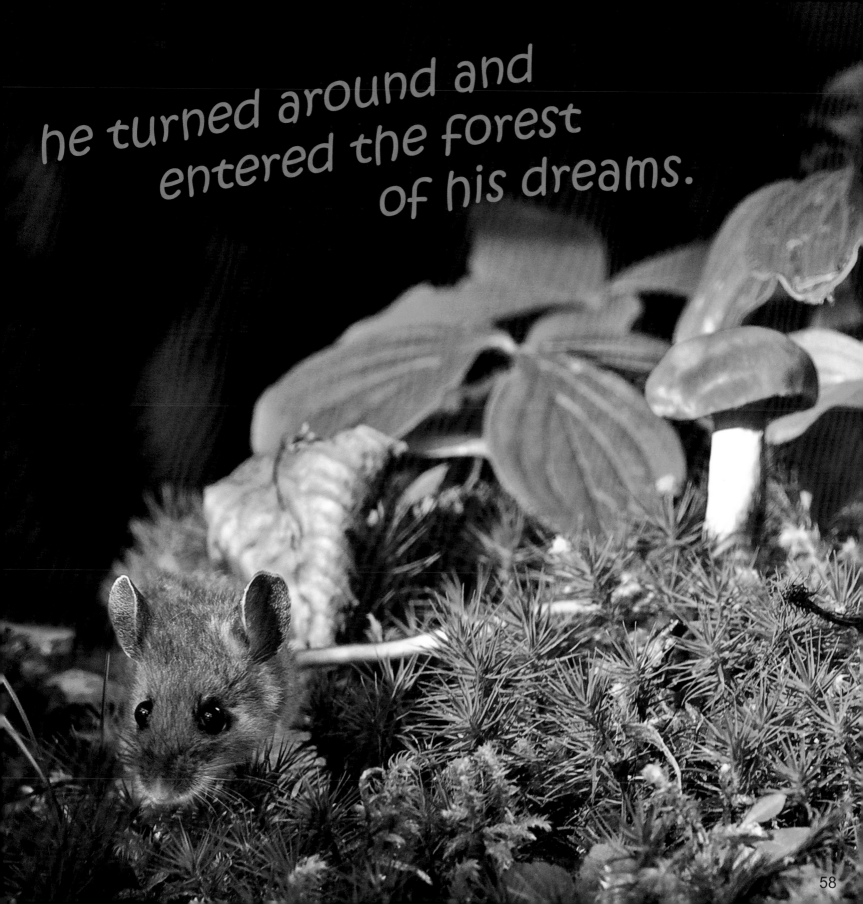

he turned around and
entered the forest
of his dreams.

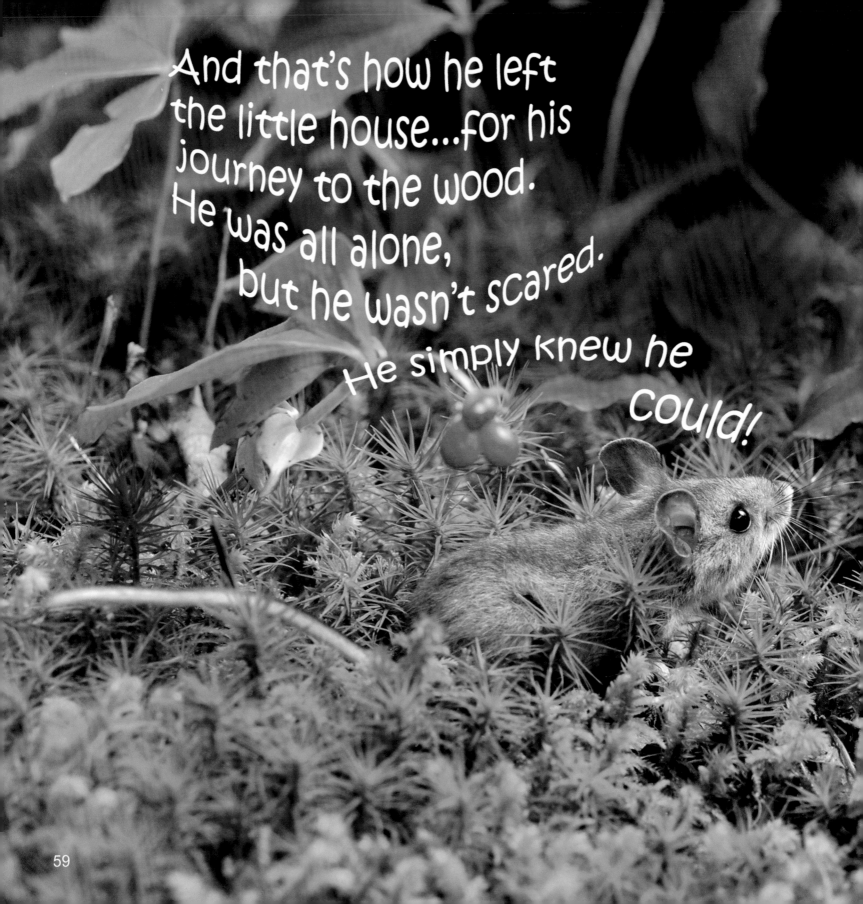

And that's how he left
the little house...for his
journey to the wood.
He was all alone,
but he wasn't scared.
He simply knew he
could!

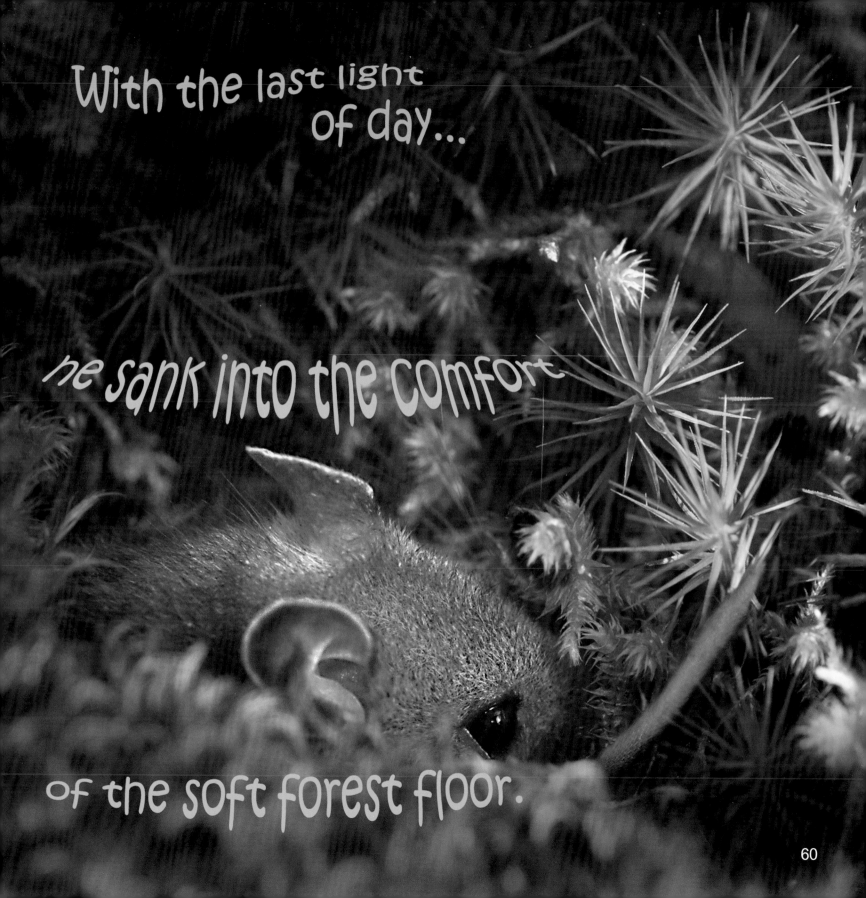

With the last light
of day...

he sank into the comfort

of the soft forest floor.

In the morning,
he woke up in the forest
of his dreams.

Sometimes the
wishes of your heart......

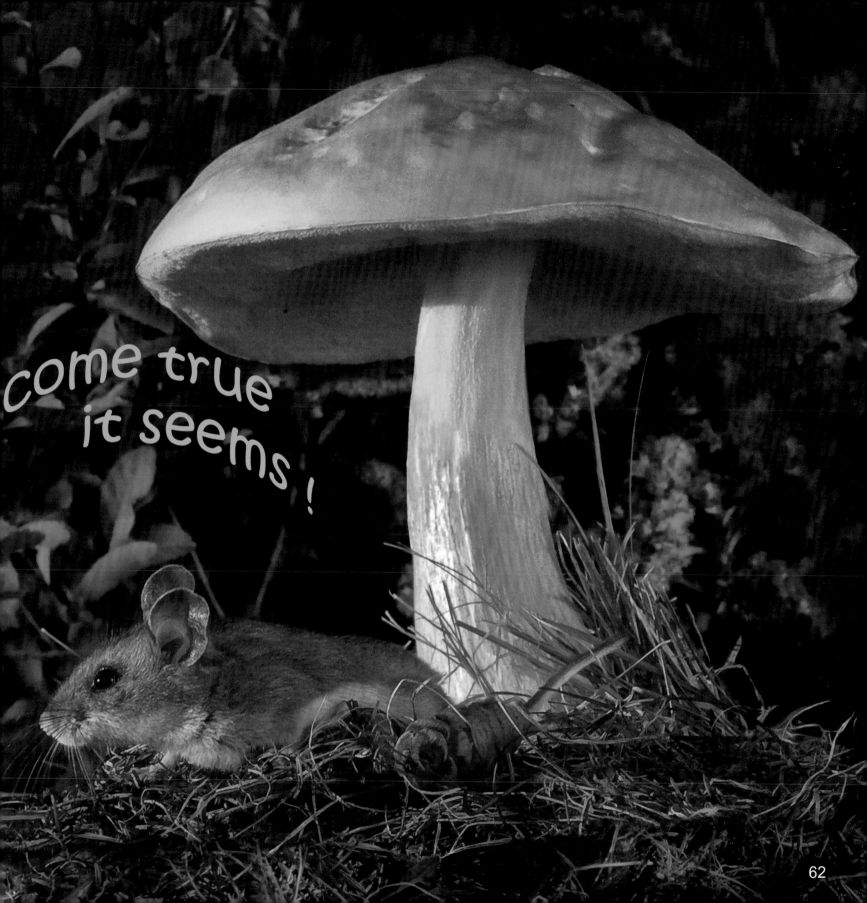

come true
it seems !

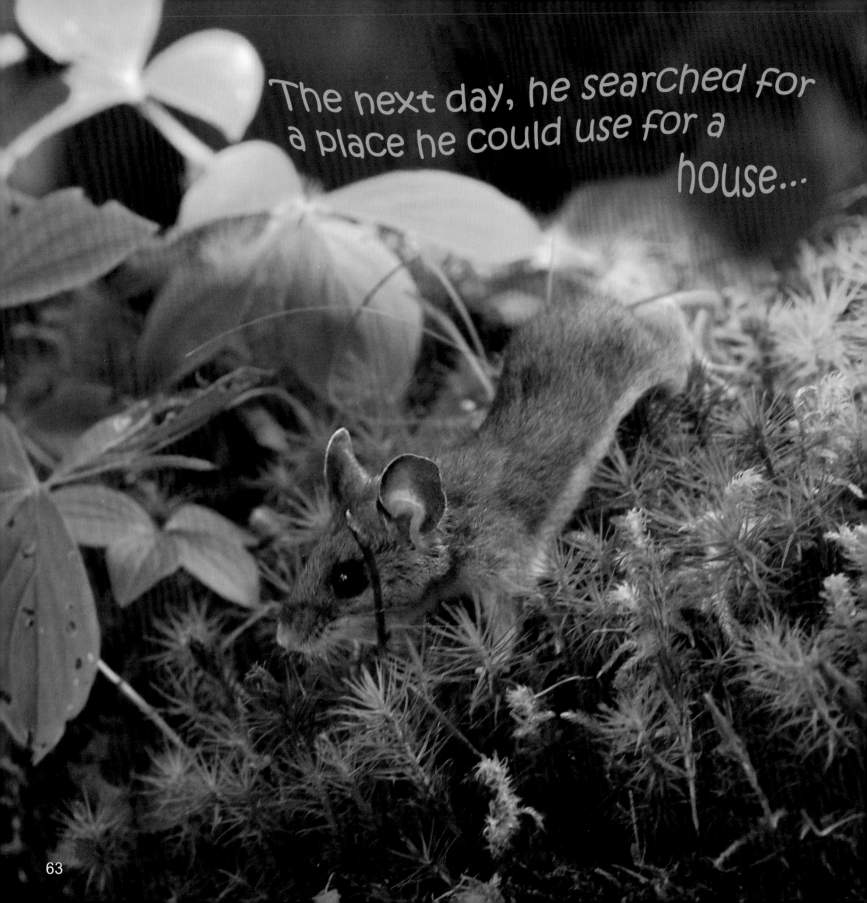

The next day, he searched for a place he could use for a house...

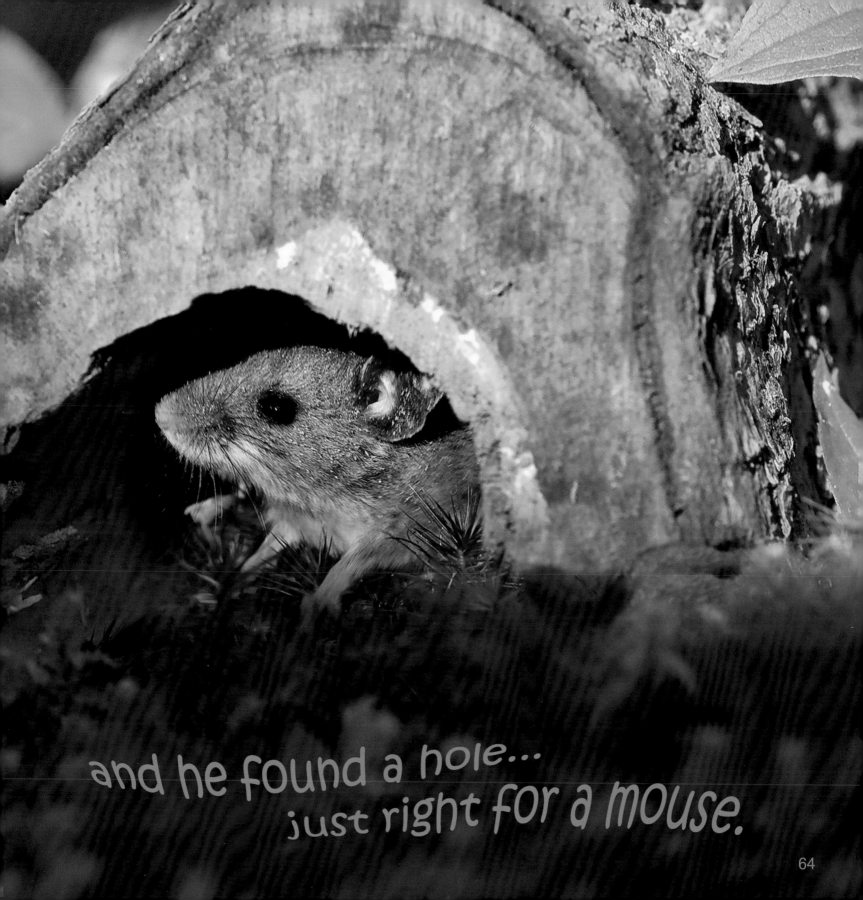

and he found a hole...
just right for a mouse.

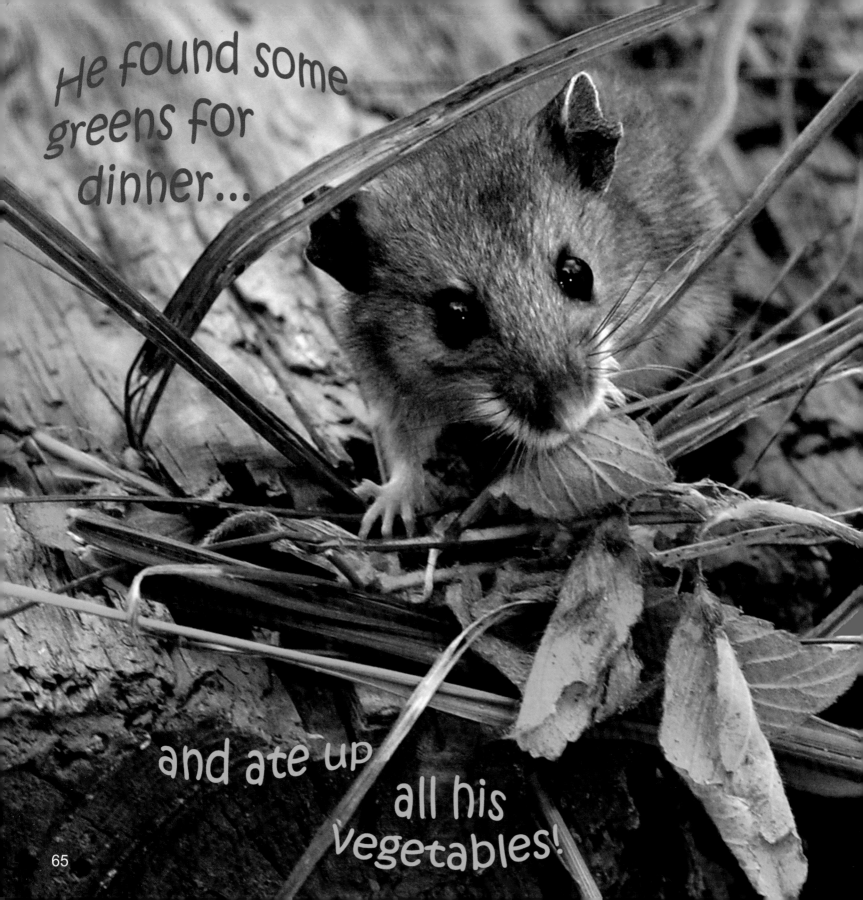

He found some greens for dinner...

and ate up all his vegetables!

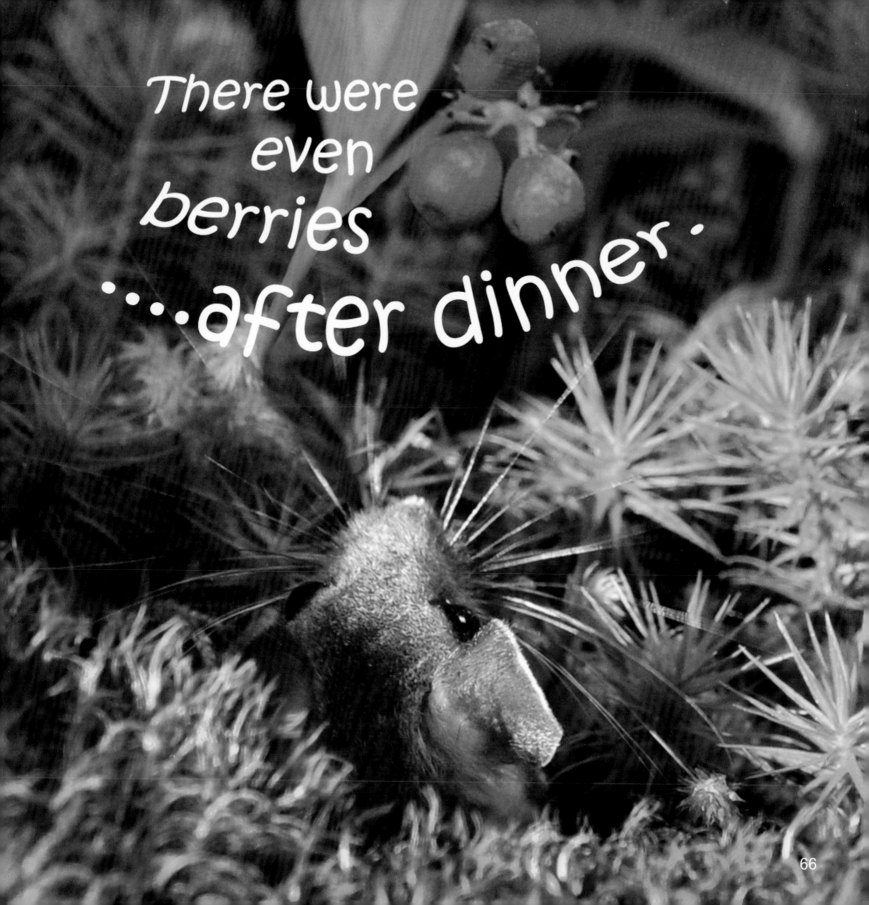

There were
even
berries
...after dinner.

And when it got dark, Teddy went to bed and had a lovely sleep.

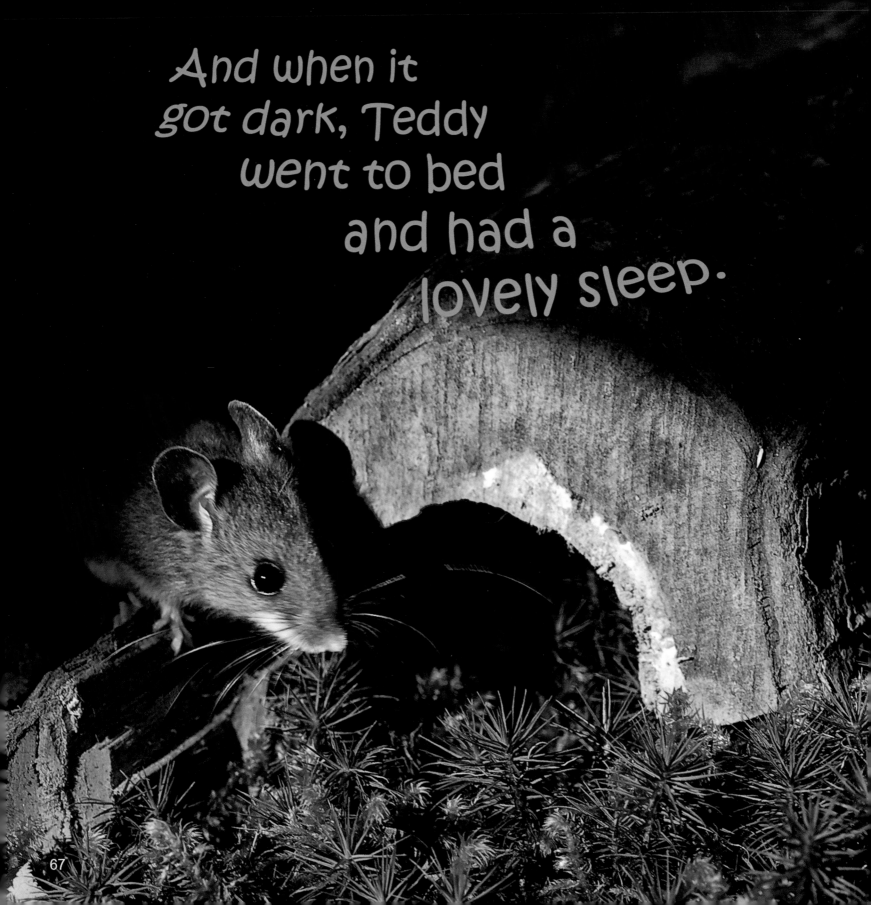

That night
he dreamed
of home....

of home....

and each familiar
face.....

and of course...... puppies in space.

And flying saucers...

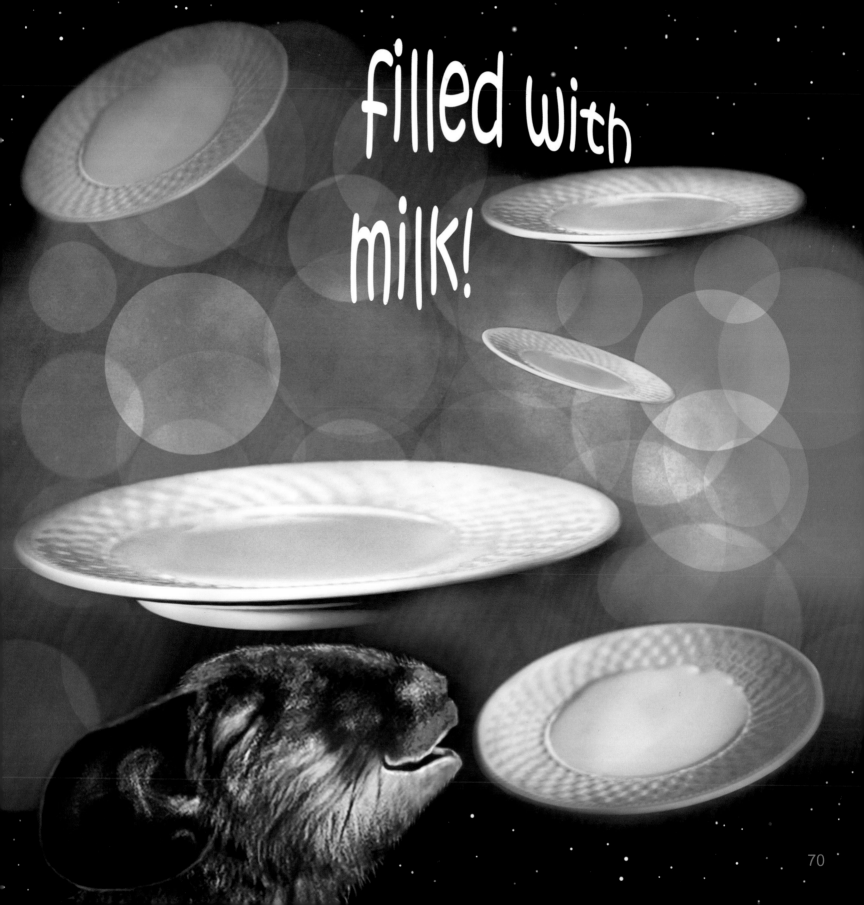

filled with milk!

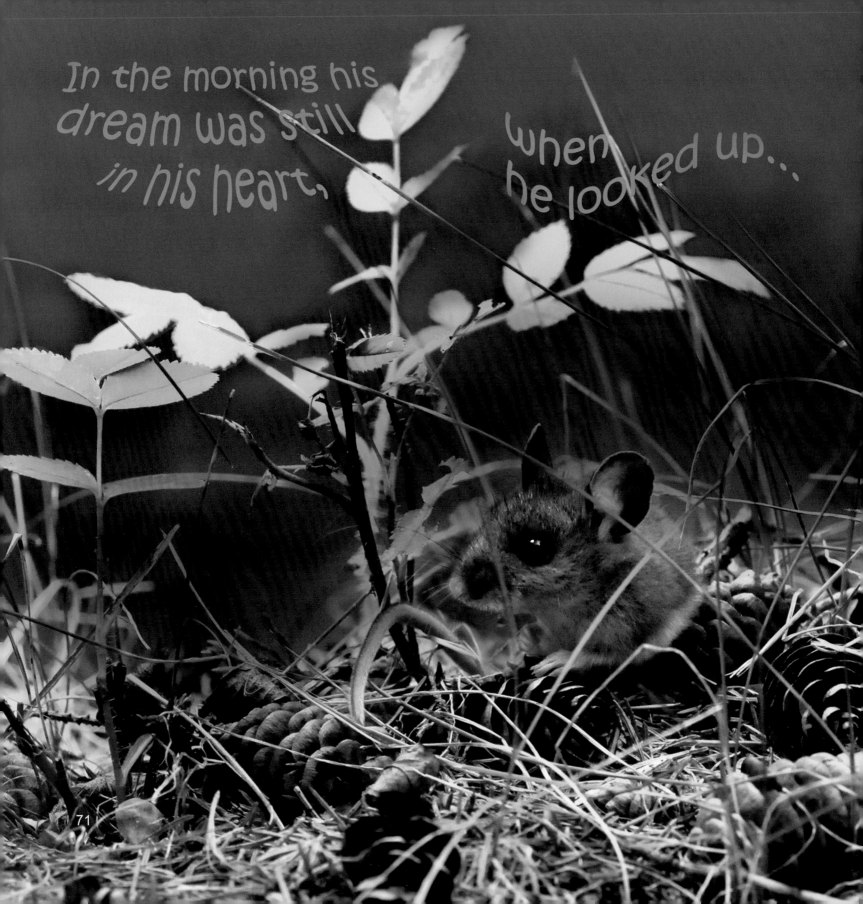

In the morning his dream was still in his heart, when he looked up...

and saw a bird with very sharp feet.

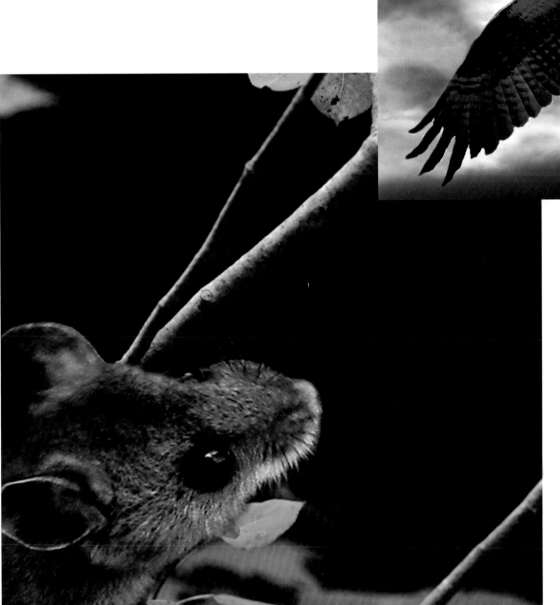

It might have been looking for something to eat!

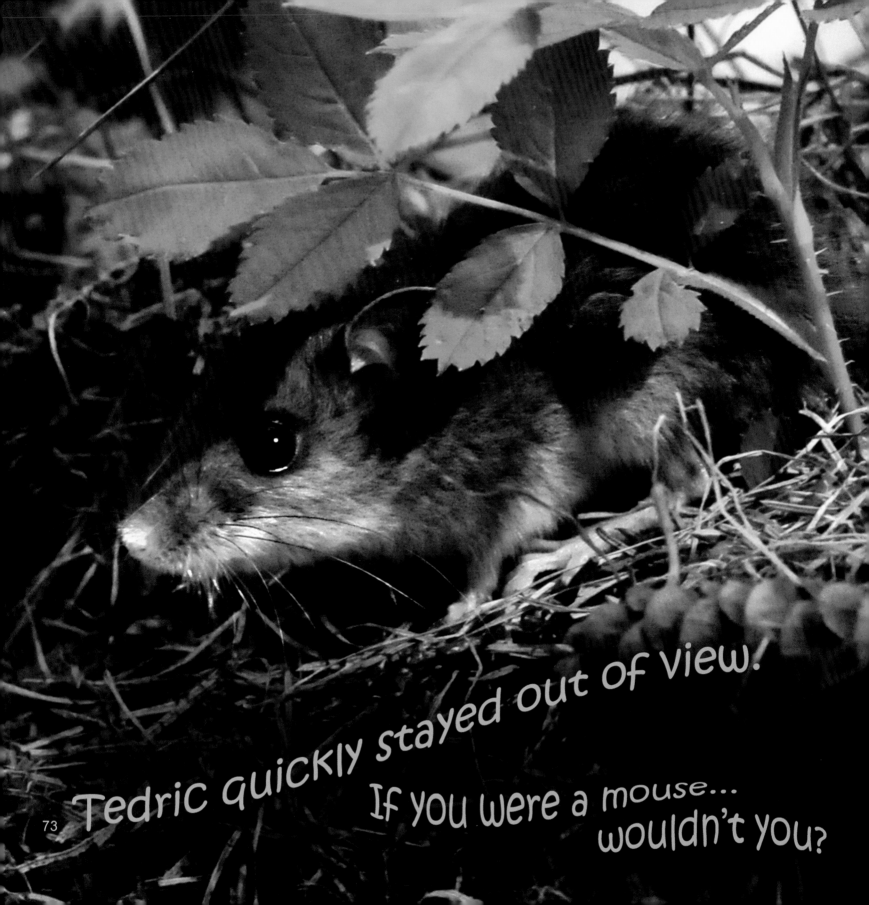

73 Tedric quickly stayed out of view.

If you were a mouse...
wouldn't you?

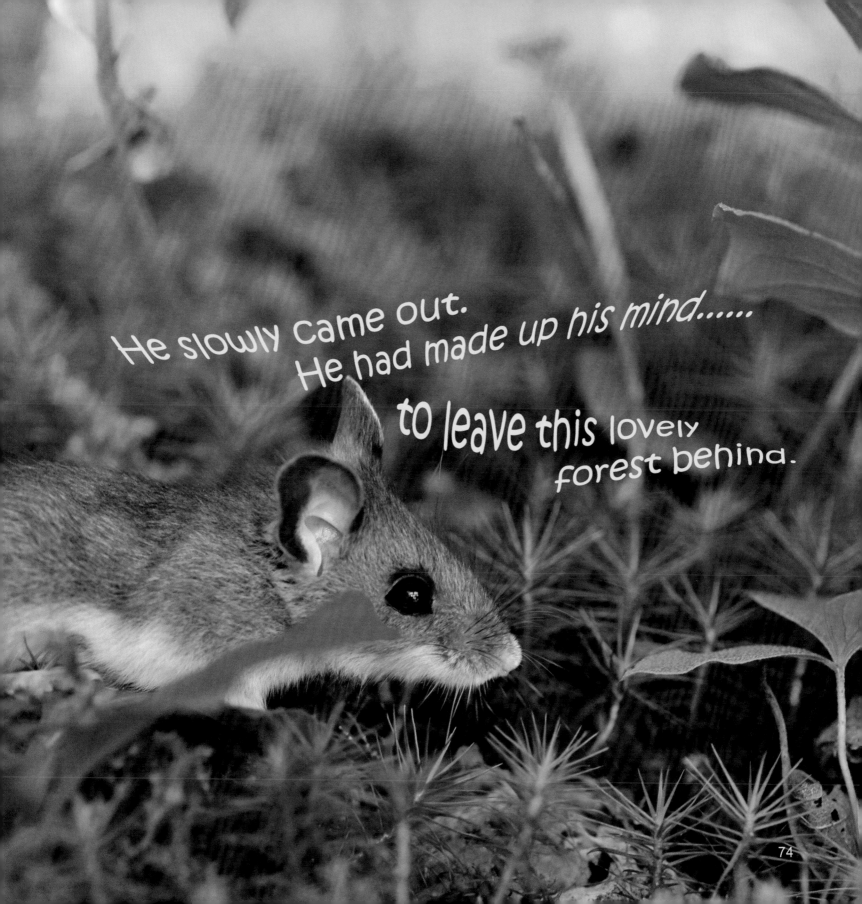

He slowly came out. He had made up his mind......

to leave this lovely forest behind.

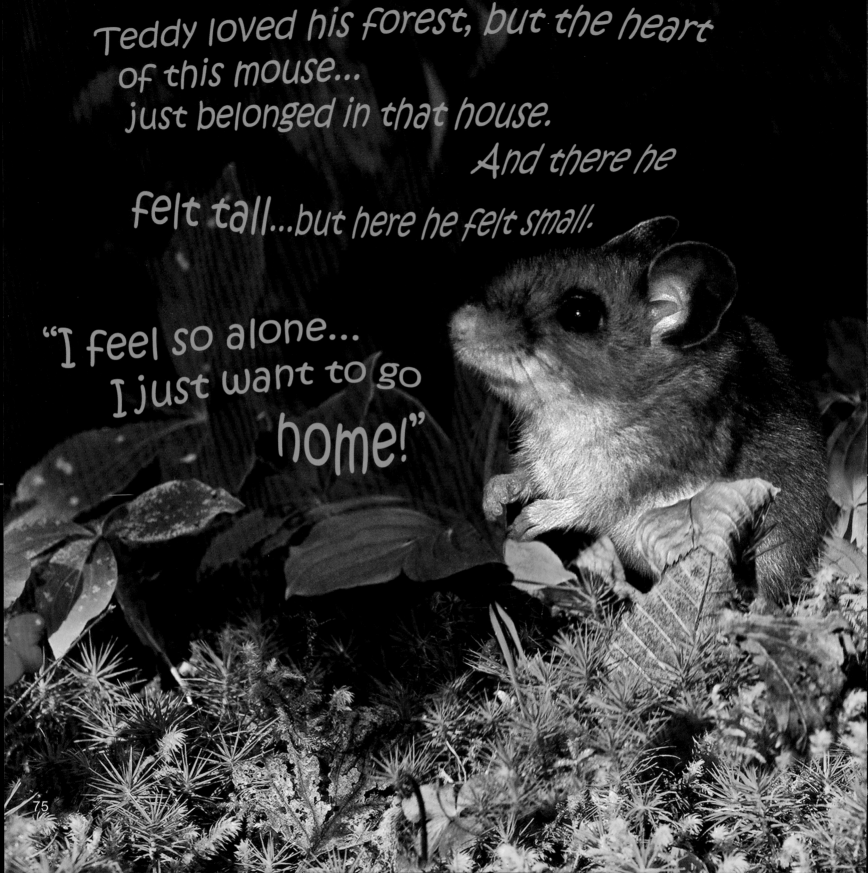

Teddy loved his forest, but the heart
of this mouse...
just belonged in that house.
And there he
felt tall...but here he felt small.

"I feel so alone...
I just want to go
home!"

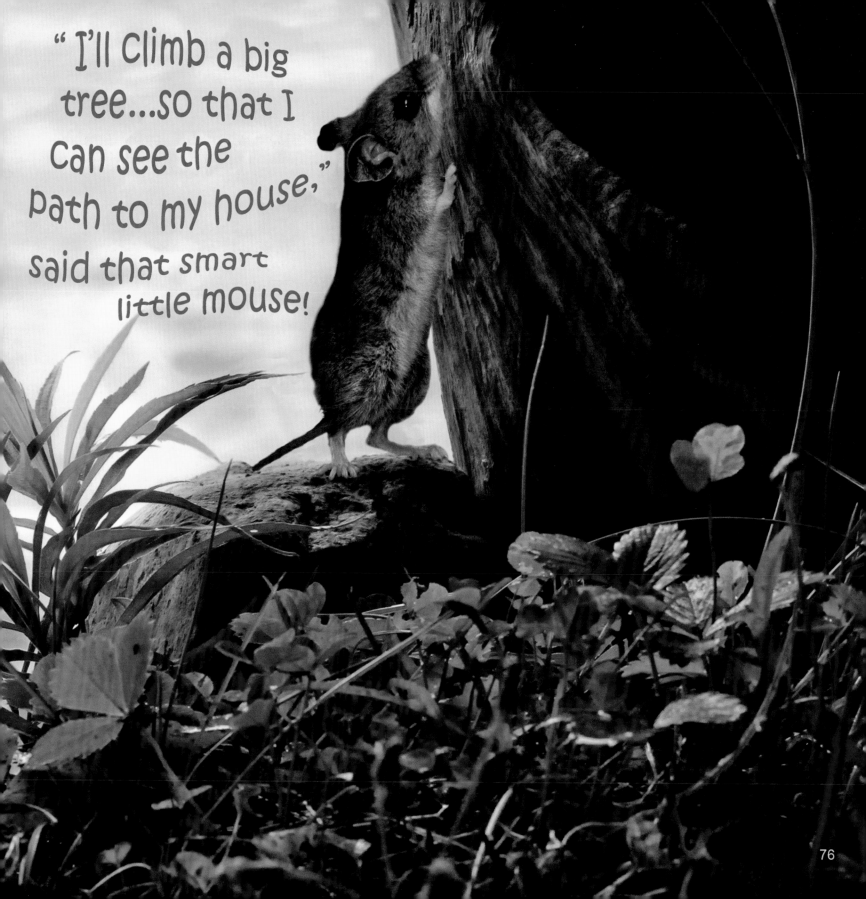

"I'll climb a big tree...so that I can see the path to my house," said that smart little mouse!

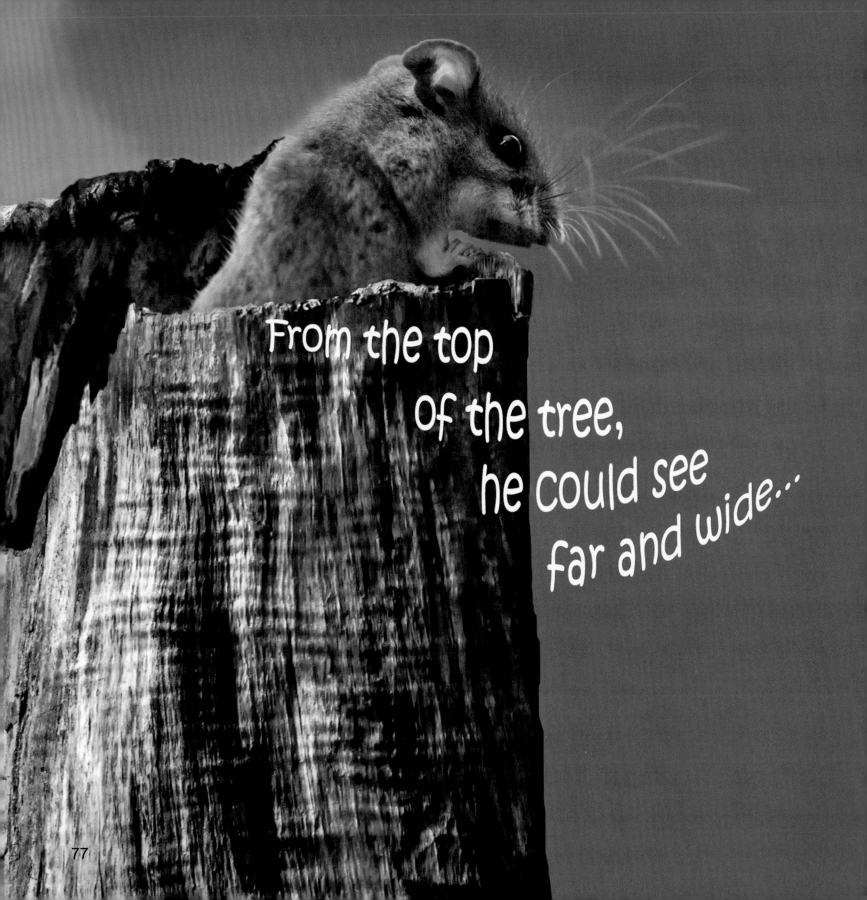

From the top
of the tree,
he could see
far and wide...

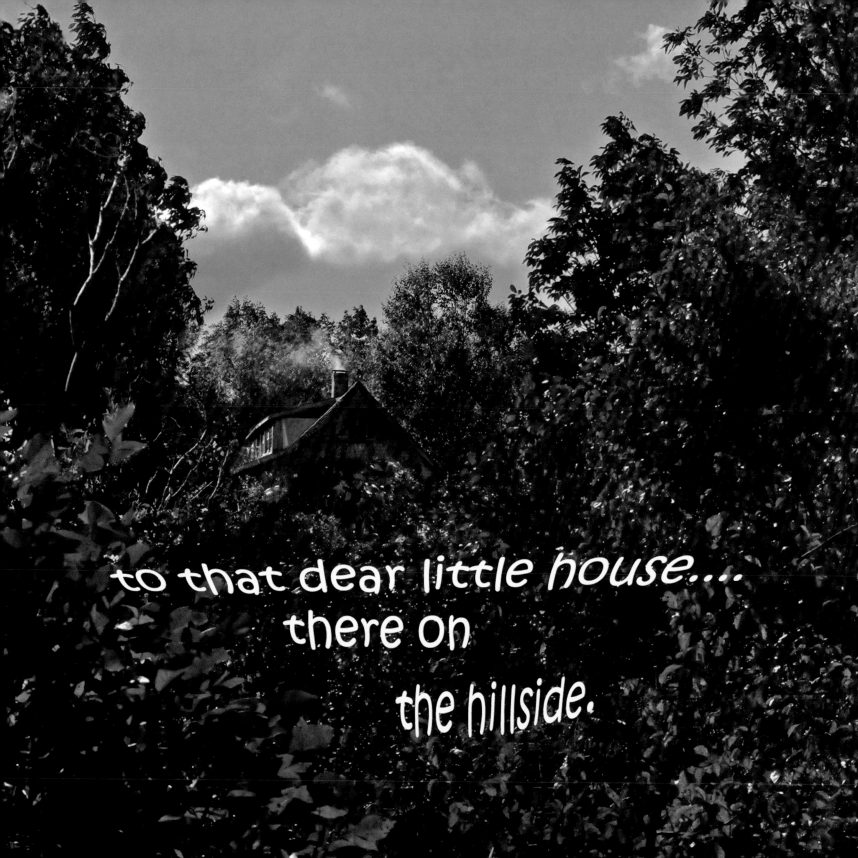

to that dear little house....
there on
the hillside.

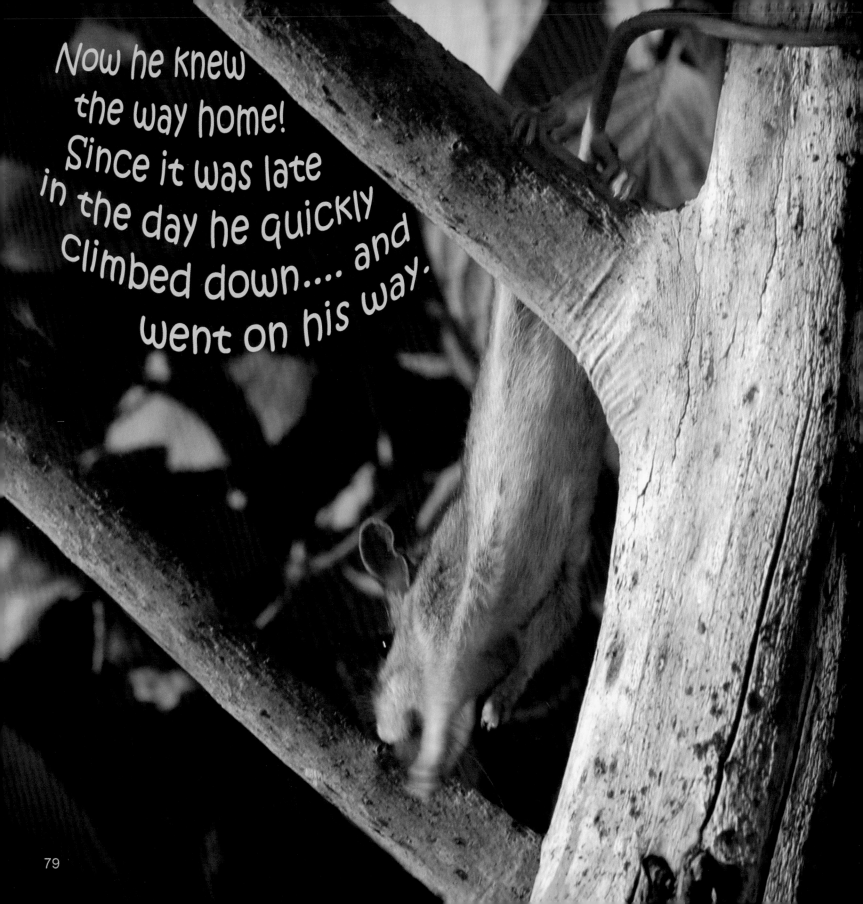

Now he knew the way home! Since it was late in the day he quickly climbed down.... and went on his way.

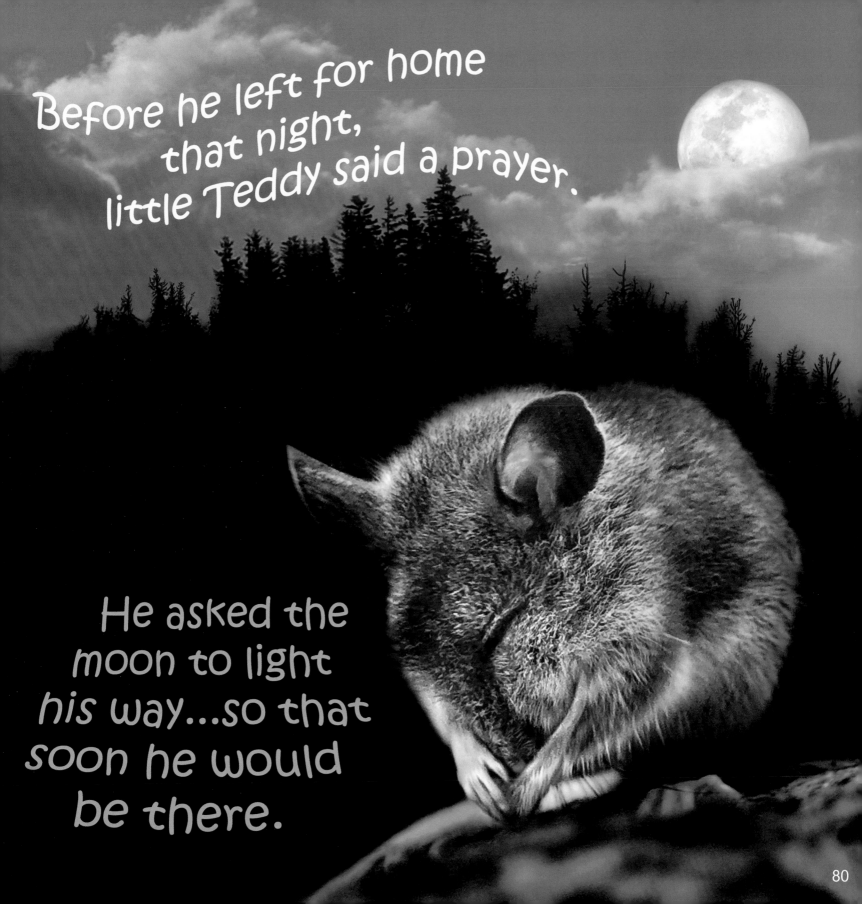

Before he left for home that night, little Teddy said a prayer.

He asked the moon to light his way...so that soon he would be there.

80

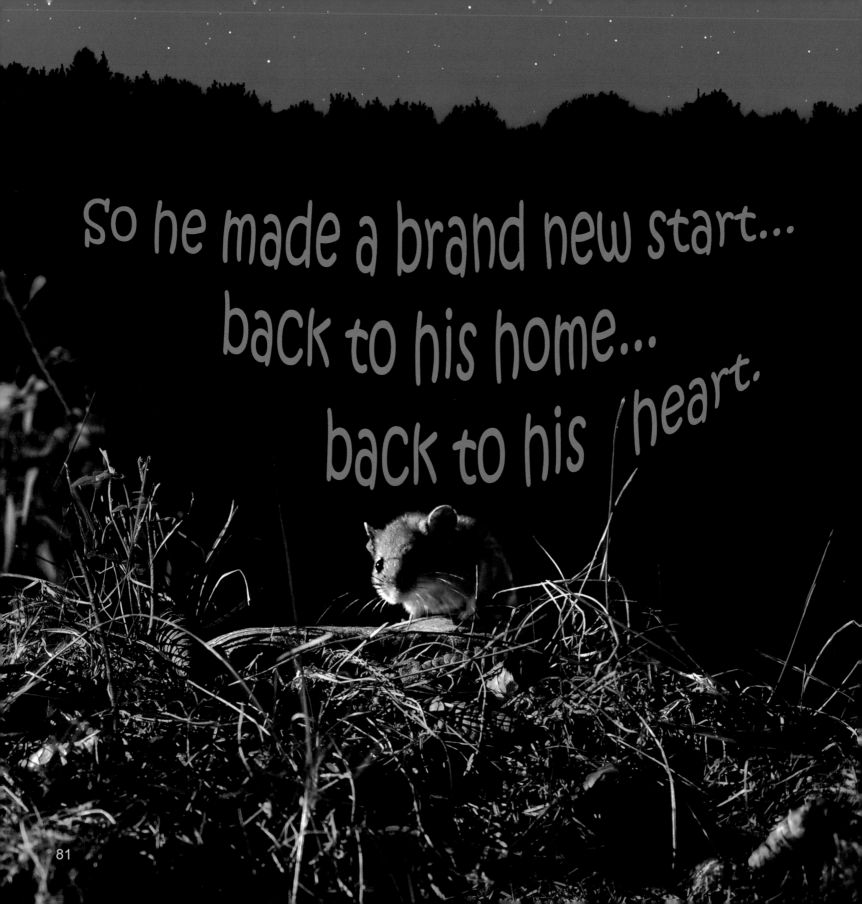

So he made a brand new start...
back to his home...
back to his heart.

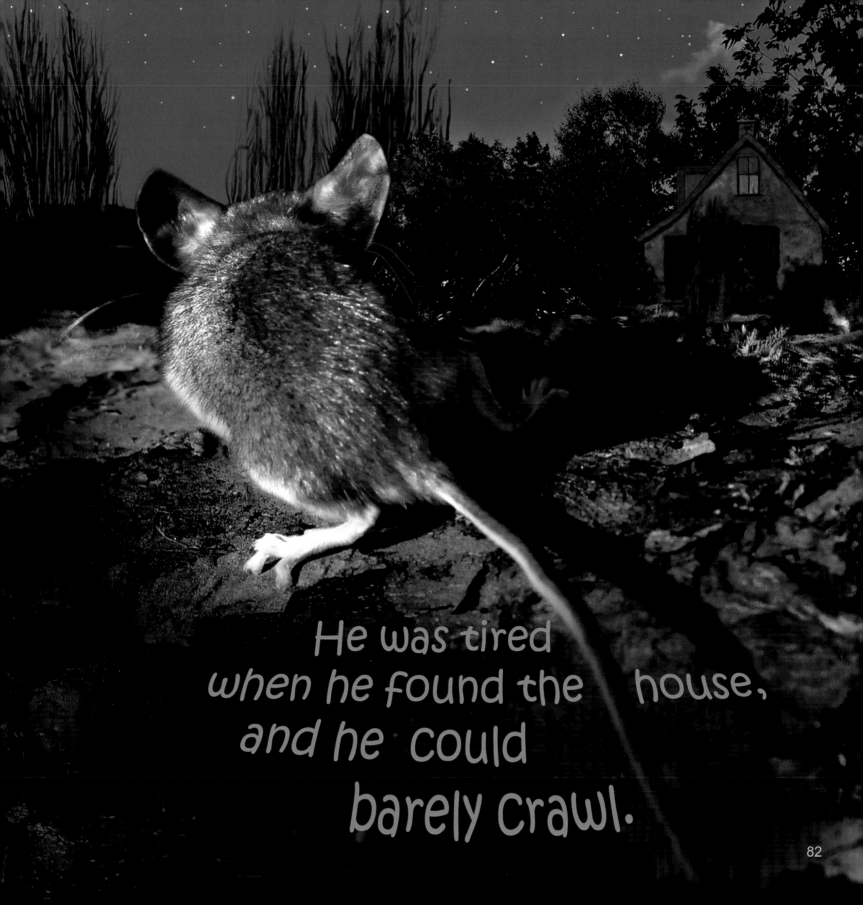

He was tired
when he found the house,
and he could
barely crawl.

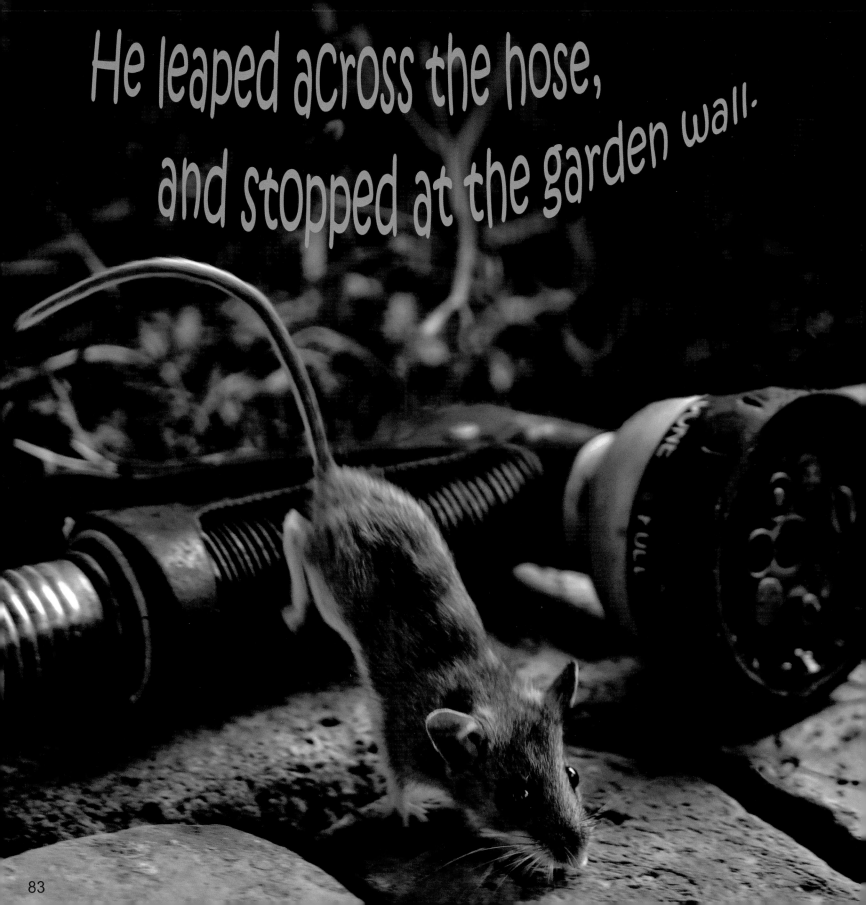

He leaped across the hose,
and stopped at the garden wall.

83

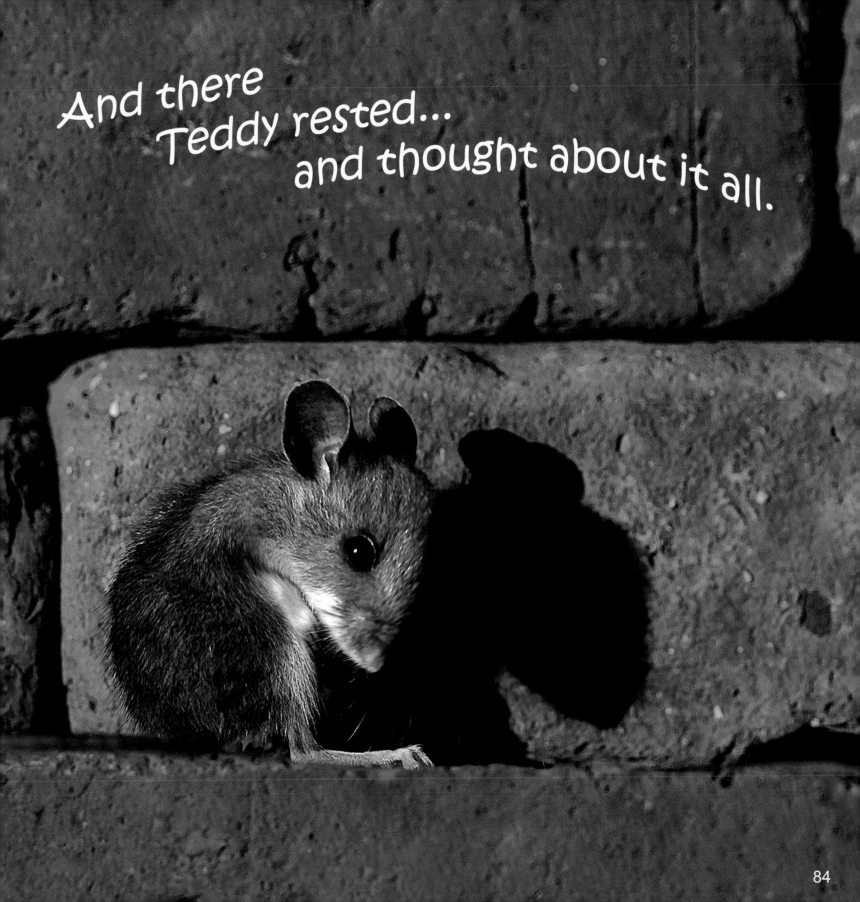

And there
Teddy rested...
and thought about it all.

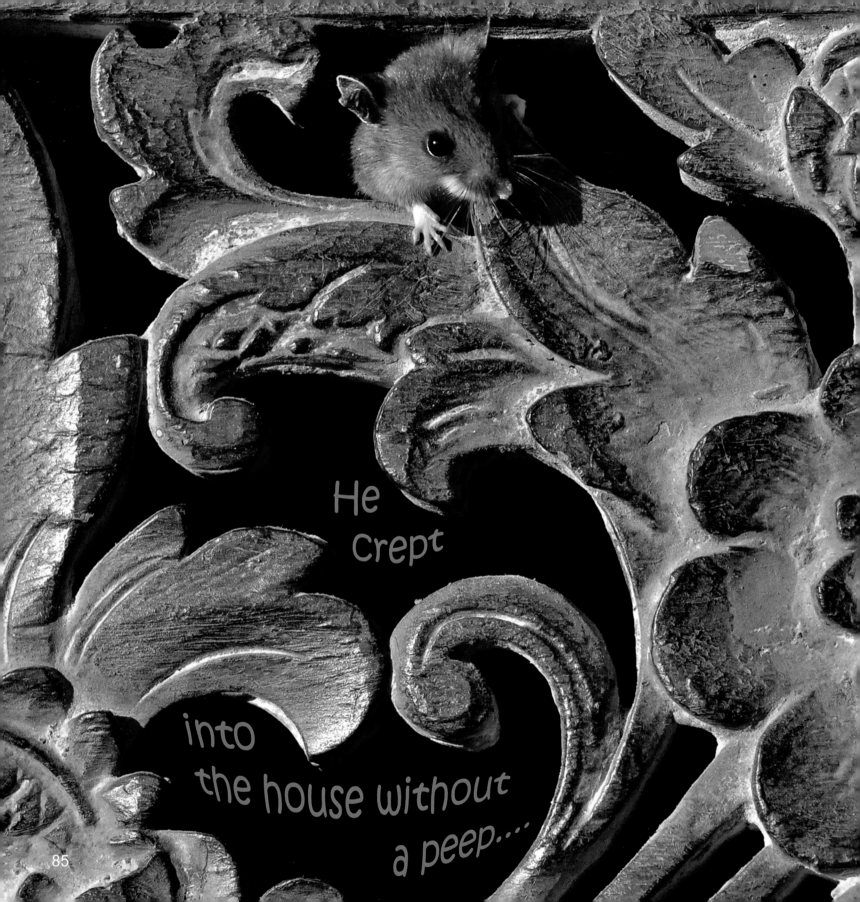

He
crept
into
the house without
a peep....

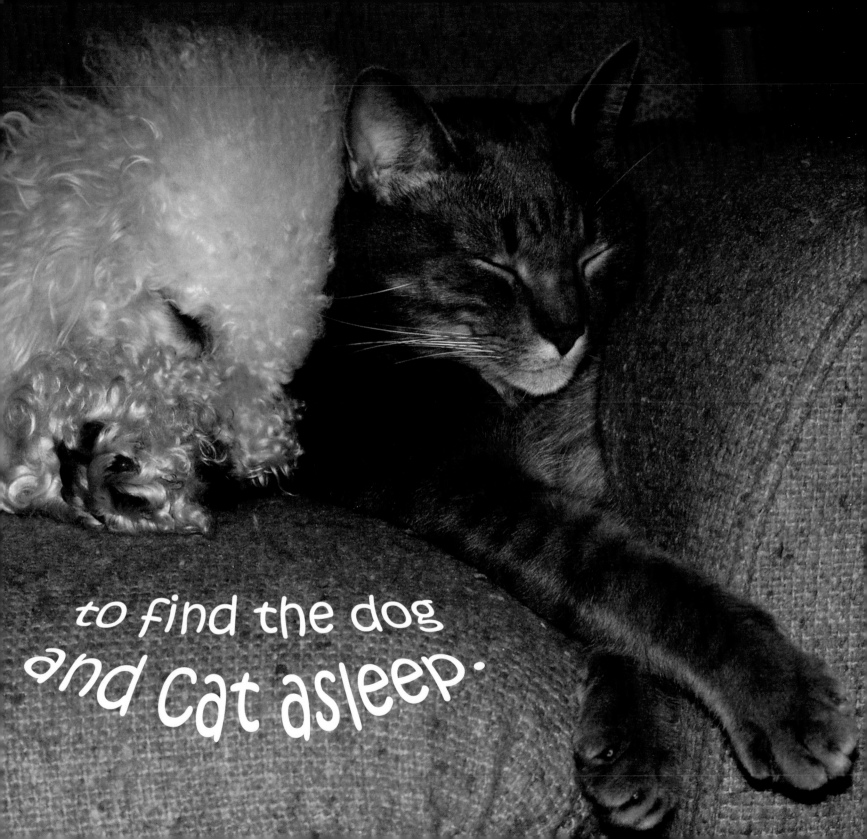

to find the dog
and cat asleep.

He crept on little feet, back to his little house....with everyone asleep, except one little mouse.

And there he found his heart!

And though it

seems so silly that
one should make a wish
yet, there in the moonlight.....
believe it or not ...
was cool milk, still in the dish !

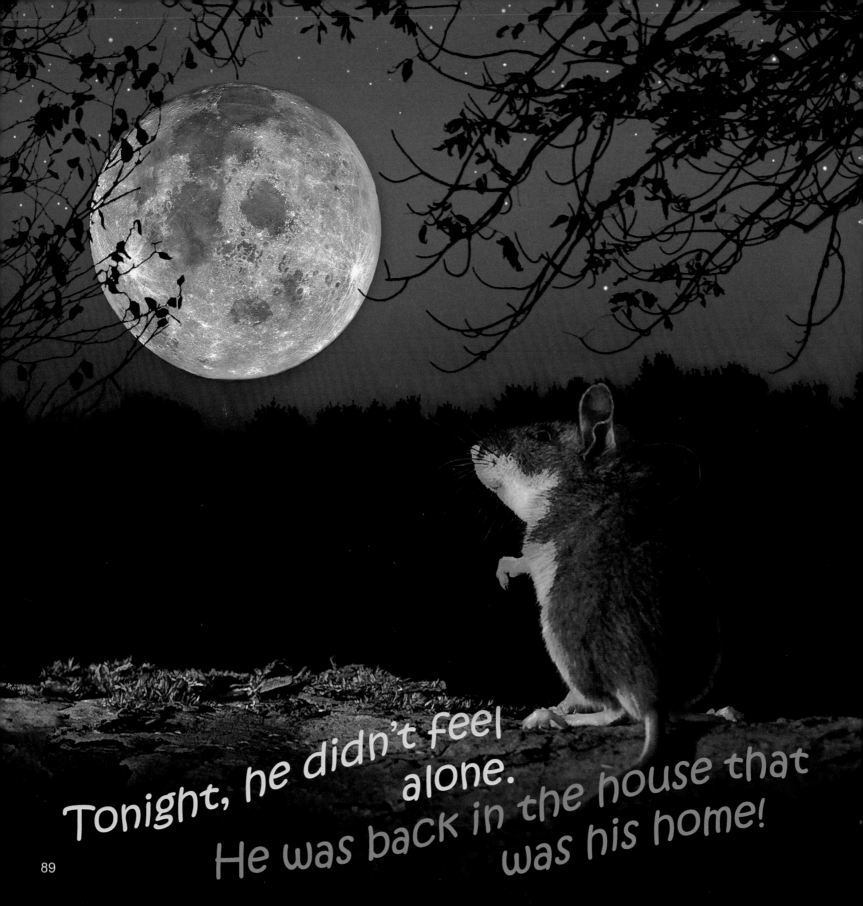

Tonight, he didn't feel alone.
He was back in the house that was his home!

And nothing was stirring in our little house, not the dog...nor the cat... just

Tedric the Mouse!

slurp slurp !

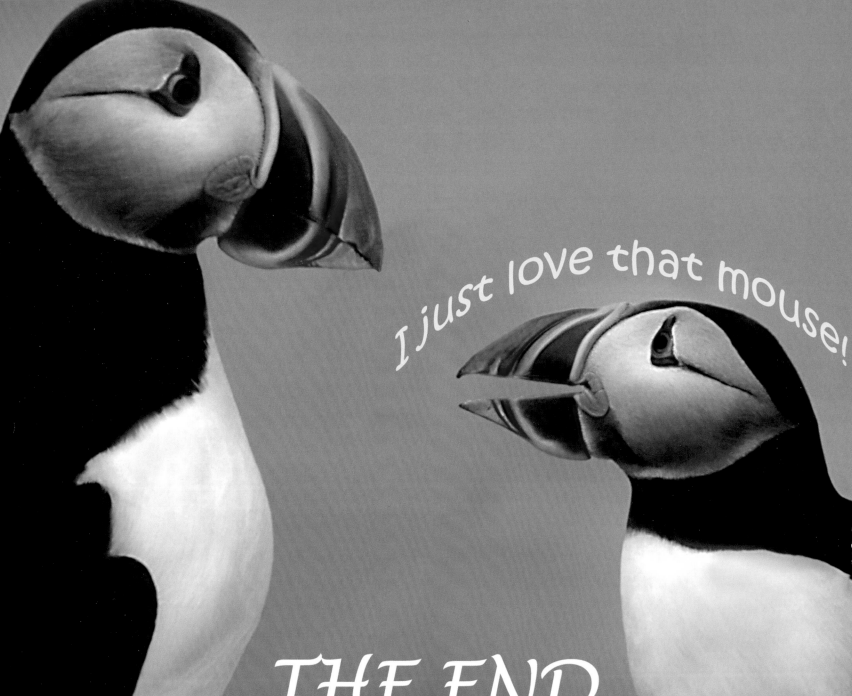

I just love that mouse!

THE END